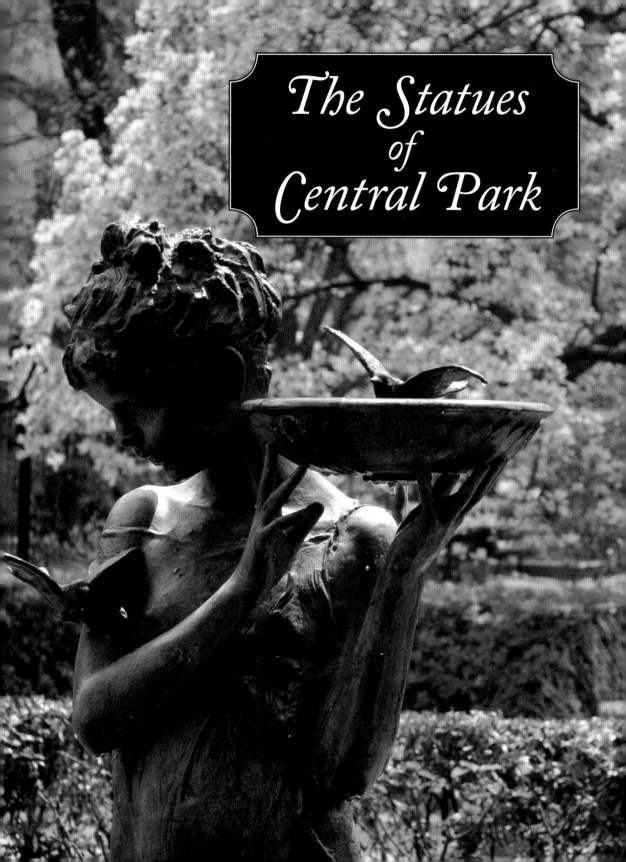

The Statues
of
Central Park

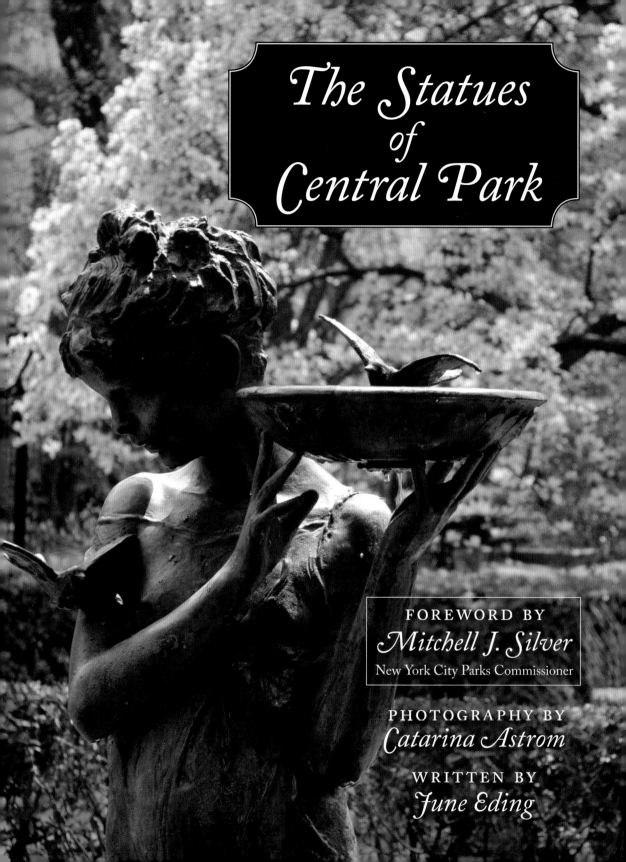

The Statues of Central Park

FOREWORD BY
Mitchell J. Silver
New York City Parks Commissioner

PHOTOGRAPHY BY
Catarina Astrom

WRITTEN BY
June Eding

hatherleigh

Hatherleigh Press is committed to preserving and protecting the natural resources of the earth. Environmentally responsible and sustainable practices are embraced within the company's mission statement.

Visit us at www.hatherleighpress.com and register online for free offers, discounts, special events, and more.

The Statues of Central Park

Library of Congress Cataloging-in-Publication Data is available upon request.
ISBN: 978-1-57826-541-1

Cover and Interior Design by Carolyn Kasper

Printed in the United States

10 9 8 7 6 5 4 3 2 1

CONTENTS

Foreword viii

Part One
Introduction
1

Part Two
The Statues of Central Park
7

Part Three
The History Behind the Art
85

PHOTOGRAPHER'S NOTE

AFTER FOLLOWING THESE STATUES IN CENTRAL PARK for over a year, it feels like they have become my friends. Prior to working on this book, I simply recognized them as most of us do; however, after befriending and fully acknowledging these statues' purpose in history, I now fully understand the power and joy that they truly project. It has been an amazing journey throughout the seasons: meeting them during the crisp fall colors, seeing them naked on cold winter days, watching them wake in the course of spring's arrival, and admiring them in a full bloom on lovely summer days. I almost felt sorrow saying goodbye to them when summer had returned and this book had been completed.

I hope that this book can give everyone a chance to take a minute to study the statues of Central Park and be inspired to visit the statues during the four seasons to admire their physical and symbolic differences. Some are hidden, others stay in their majestic position, looking out over the park where no one can miss seeing them. But I promise that in this book you will see them all as I have walked miles upon miles in the different seasons,

even wearing down my favorite pair of shoes—my Central Park shoes, as I like to call them now.

Central Park has long been known as the "Lung of New York", and I now understand why. As soon as one comes to visit the park again and crosses paths with one's friends, one can take a deep breath as all chaos seems to disappear from beyond the hectic perimeter of the park, filled with millions of inhabitants, tourists, and daily visitors.

Which statue is my favorite? I really don't know. I love to pet little Balto and to look at Hans Christian Andersen, who comes from Scandinavia where I grew up with him. I love to see the children play at Alice in Wonderland, study the majestic King Jagiello, meet the cougar looking out from his hidden spot on a hill where many runners quickly pass by, and see the birds be part of the Burnett fountain when they share the water with the bird statue. I also love to see how people walk through the Mall and cast their eyes on Robert Burns, Sir Walter Scott, Fitz-Greene Halleck, William Shakespeare, and Christopher Columbus. And I like to look out over the majestic Bethesda fountain and see people rowing out from the boathouse. Central Park statues are all so different, and together they make Central Park so great.

Step in, enjoy them all in their different sceneries, and I am sure that you will get the same joy as I have attained.

—CATARINA ASTROM

FOREWORD

PARKS ARE MAGICAL PUBLIC SPACES. THEY ARE PLACES where we can escape the busy city streets, retreat to for relaxation, and connect with nature, friends and family. Parks also offer benefits to our physical and mental well-being. Parks are free to all, and are magnets for New Yorkers and visitors alike. So it is no surprise that Central Park attracts more than 42 million visitors a year.

Parks have become outdoor art galleries that showcase past and present culture with permanent and temporary art. This book celebrates the former: the amazing collection of permanent art dispersed throughout New York City's and the world's most iconic park, Central Park, and its 843 acres.

As a native New Yorker and now New York City's Parks Commissioner, I must confess I paid little attention to the 800 monuments throughout New York City's parkland. I only used them as landmarks to offer directions or as a place to meet a friend, since most parks don't have street addresses to use. That is why I am so pleased that this beautifully illustrated book has been written to showcase the monuments and sculptures erected in Central Park.

In 1863, New York City was given a gift that would transform the American landscape forever. Central Park became the first landscaped park in the United States. Designed by Frederick Law Olmsted and Calvert Vaux, this landscaped green space was intended to be a pastoral oasis in the center of Manhattan, one that would be a free and democratic public space for all to enjoy. Central Park became the people's park, regardless of race, income or social status.

Central Park, in and of itself, is a picturesque work of art. And, over time, the Park also became an outdoor art museum, as individuals and organizations donated sculptures and monuments to co-exist within this cherished public space. There are 141 sculptures and monuments in Central Park, which include a range of historical figures, fictional characters, war memorials, artists, scientists, writers, poets, and animals.

People go to parks for an experience. Each person customizes their experience based on their time, needs, and curiosity. While some may visit Central Park to see specific sculptures and monuments, many others encounter them by chance as they journey through the undulating paths and rolling landscape.

Cities contain layers of history, as does each monument; they tell stories about the individual work of art, the context of the time it was installed, as well as the contribution of the person or event. Even fictional characters such as Alice, from the classic book *Through the Looking Glass*, near East

74th Street, and animals such as Balto the sled dog, located near the Children's Zoo, offer visitors memorable photo opportunities and a glimpse into history.

The City of New York Department of Parks & Recreation must be commended for maintaining and preserving the 800 monuments in Central Park and across five boroughs. In the 1930s, the Parks Department created a small in-house maintenance crew, but by the 1980s the city budget no longer allowed the Parks Department to maintain the monuments to an acceptable standard of care, and consequently many sculptures fell into a state of neglect. In 1991, the Parks Department partnered with the Central Park Conservancy (the non-profit organization that helps to operate and maintain Central Park) to launch a monuments preservation program to address the conditions of the collection in Central Park. The benefits of this public-private partnership can be seen today and are captured in *The Statues in Central Park*.

From the very first sculpture installed in the park in 1859 (the bust of Johann C.F. von Schiller, a romantic dramatist, poet and philosopher) to the latest (Susan B. Anthony and Elizabeth Cady Stanton Women's Suffrage Movement, to be installed in 2020), I am personally grateful to June Eding and Catarina Astrom for producing this book, spotlighting the statues in Central Park. I hope you will enjoy the journey, and if you have not been

to Central Park, I hope this book will inspire *you* to visit and experience the beautiful landscape and the world's largest outdoor art museum in person.

—MITCHELL J. SILVER, Commissioner,

New York City Department of Parks & Recreation

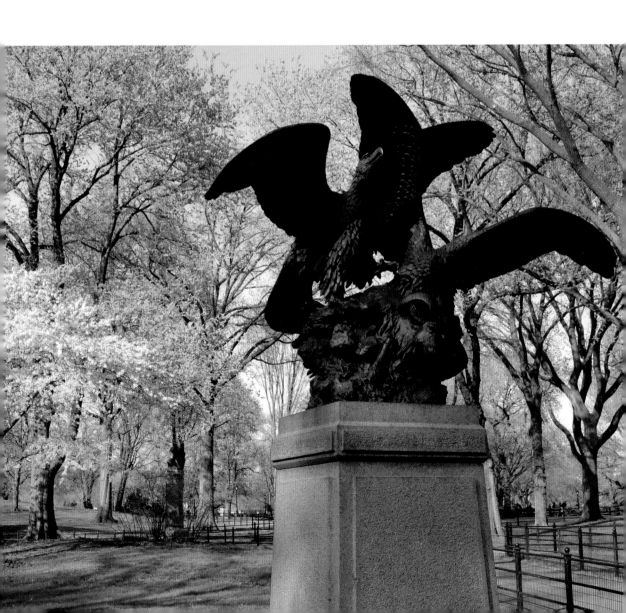

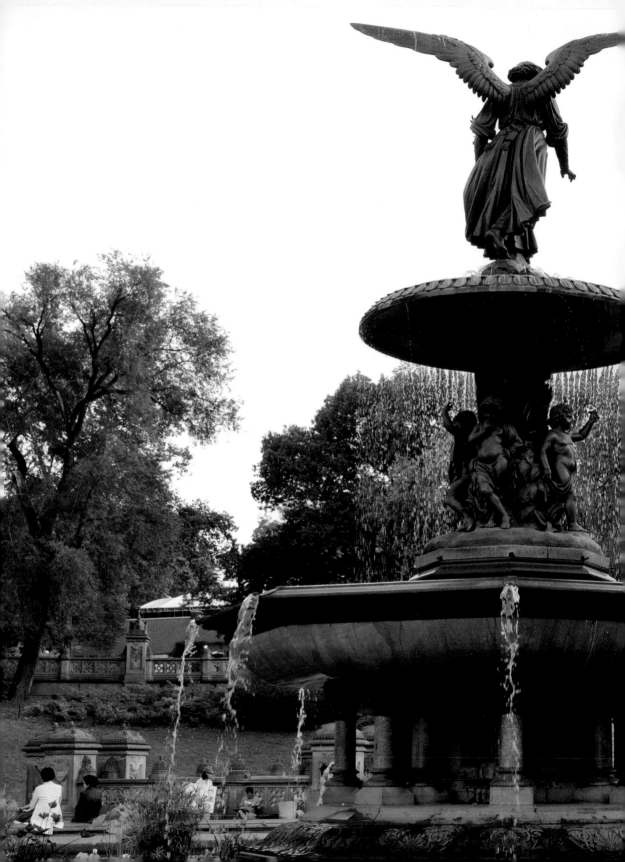

PART ONE
INTRODUCTION

NEW YORK CITY WOULDN'T BE THE REMARKABLE CITY that it is without the breathtaking landscape of Central Park. Clad in white in winter, bursting with colorful flowers in spring, a green respite during summer and a stunning kaleidoscope of color in the fall, the expanse of Central Park displays the majesty of the seasons for anyone to enjoy. A source of life and renewal, Central Park is, for many, the heart of Manhattan.

Reaching across the east and west sides of the city and stretching over 800 acres from mid-town Manhattan at 59th street to its high point in Harlem at 110th, the Central Park we know today is the result of expansions completed in 1873 by designers Frederick Law Olmsted and Calvert Vaux.

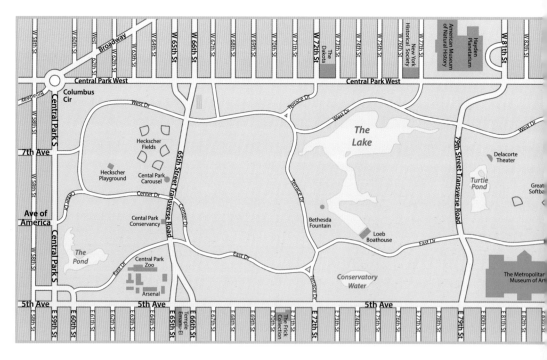

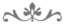

New York City in the 1800s needed a substantial public park to accommodate a population that was growing in leaps and bounds: the number of city dwellers nearly quadrupled between 1821 and 1855, and the demand was great for open spaces to relieve residents from cramped urban living. Olmstead and Vaux responded with a Park design that transported visitors out of the city into a rustic landscape. They planted thousands of trees, flowers, and plants from around the world, bringing a wonderland of flora and fauna to the city's doorstep. They added elegant bridges and expansive lawns and created curving paths to explore. From the day of its completion in 1873, the Park transformed city life, offering residents restoration and a place to enjoy leisure time outdoors. Through the decades, the Park has become almost a

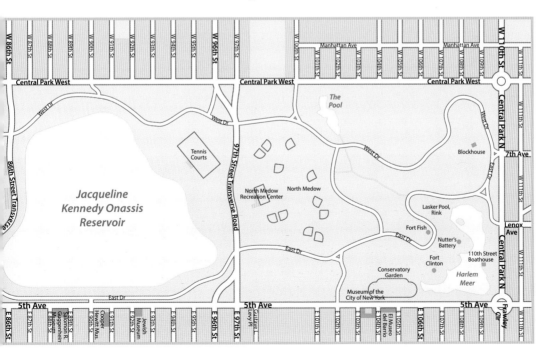

second home outside of crowded apartments for thousands, providing New Yorkers with a place to experience nature and come together for fresh air, exercise and fun.

Over the years, Central Park's history has been marked by great leaps of change and growth. From 1864 until 1934, actual sheep grazed in the Sheep Meadow, and Depression-era shantytowns once dotted the Park before being removed to free open space for the Great Lawn. The Park was designated a National Historic Landmark in 1962, and underwent important periods of renovation and improvement to its lawns, ponds and fields. Today, in addition to providing a window to the natural world, the Park also offers multiple venues for recreation and socializing, including an outdoor theater for live performances, fields for softball and baseball, bicycle paths, a zoo, a carousel, a sailboat pond, and plenty of vendors selling hot dogs and ice cream. On any given day, the paths of the Park are energized by visitors from across the city and around the world enjoying all it has to offer. Indeed, although the majesty of nature is on full display throughout the Park, people bring Central Park to life. It is when visitors explore wooded areas to enjoy bird watching, walk along winding paths and discover new trees and flowers, picnic together on expansive lawns, or relax beside quiet ponds, that the Park fulfills its purpose.

The sculptures scattered across Central Park are as much a part of the Park as the people who have visited over the years. For anyone who explores

the Park, the sculptures are wonderful surprises that provide the opportunity to learn and reflect. Sculptures honoring great men and women, from inventors and explorers, to activists, philosophers and patriots, to composers, musicians, playwrights, poets and more, celebrate the power of human accomplishments. Placed in the Park over the centuries, they provide glimpses into another era and offer three-dimensional lessons in art and history. The sculptures also count a wide variety of animals in their ranks, including some that call the Park home. Animals depicted in metal and stone complement the wonder of nature and remind us that we are duty-bound to protect the animals that share our world. Imaginative sculptures inspired by children's books, poems and plays remind us of the power of human creativity to conjure worlds that transform everyday life.

Each of Central Park's sculptures is a new opportunity for viewers to contemplate a distant past, be awestruck at nature's wonder, or let their imaginations wander far out of the city to worlds beyond. From the sailboat pond to gardens north of 86th Street, to the Literary Walk and rock formations by the crosstown transverses, the sculptures of Central Park showcase remarkable pieces from the art of sculpture and allow us to ponder the distant periods in our own history, while honoring the incredible true stories of the men and women whose contributions have made our world a better place.

ERECTED BY THE
NEW ENGLAND SOCIETY
IN THE CITY OF NEW YORK
1885

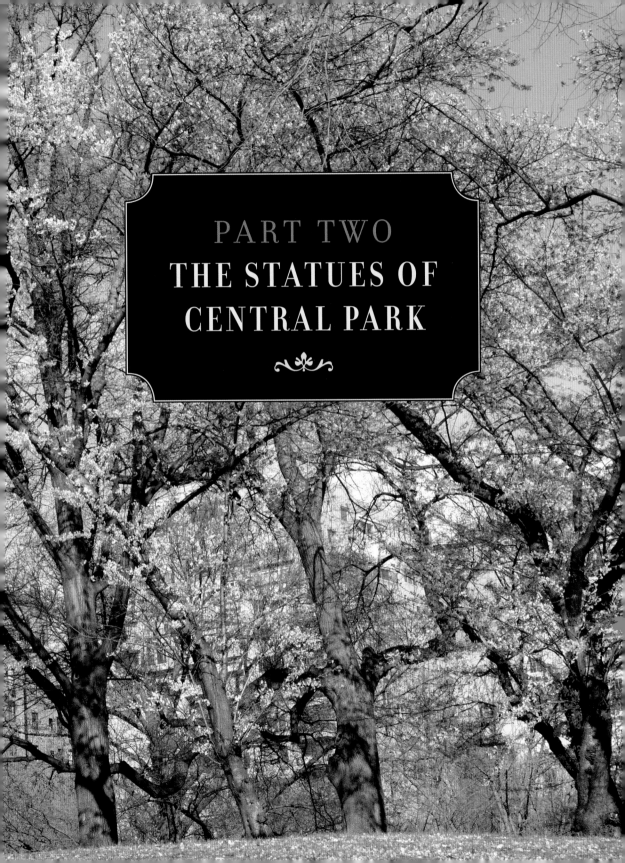

PART TWO
THE STATUES OF
CENTRAL PARK

❧

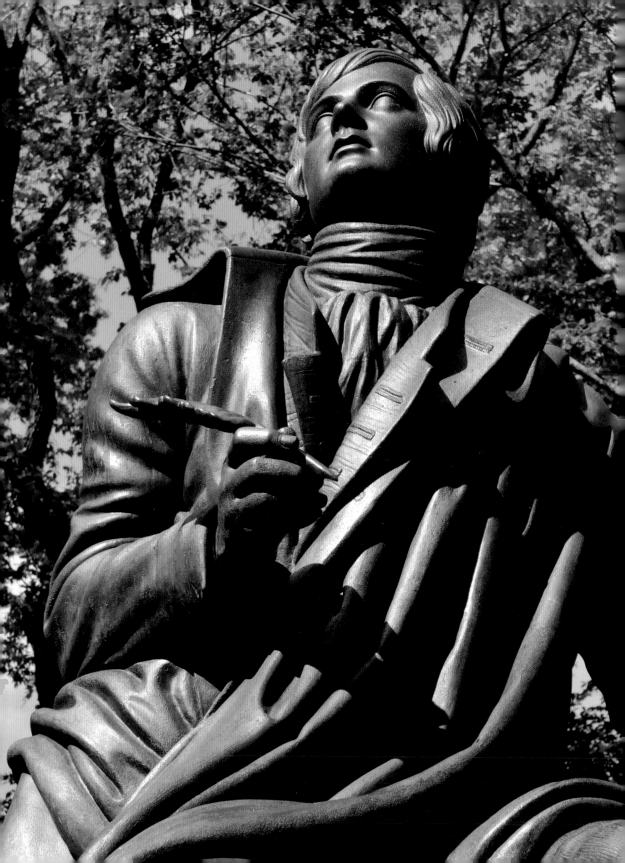

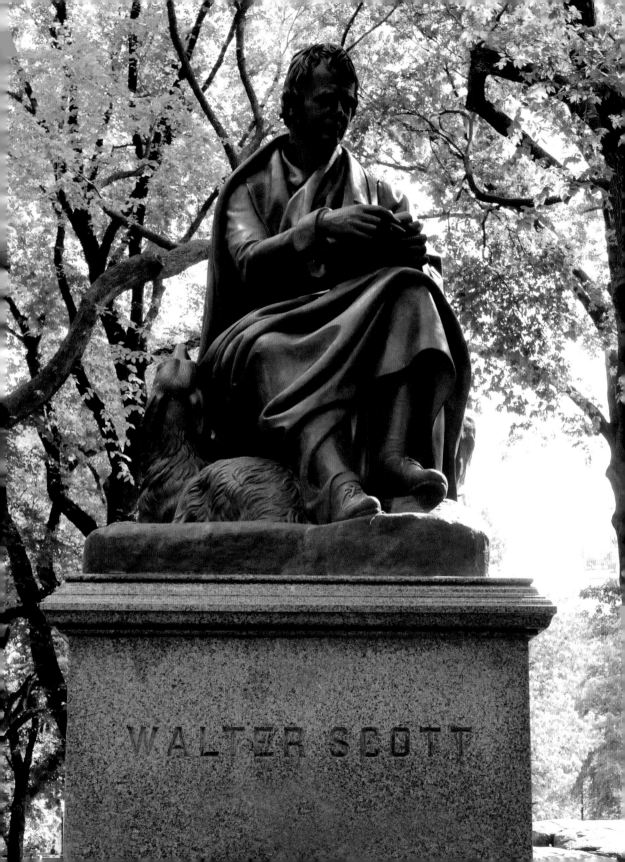

WALTER SCOTT

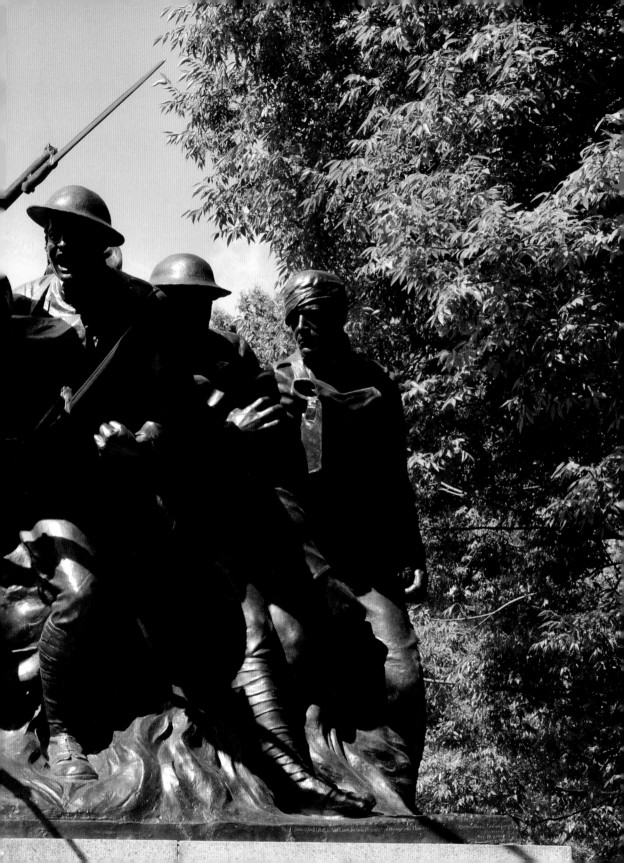

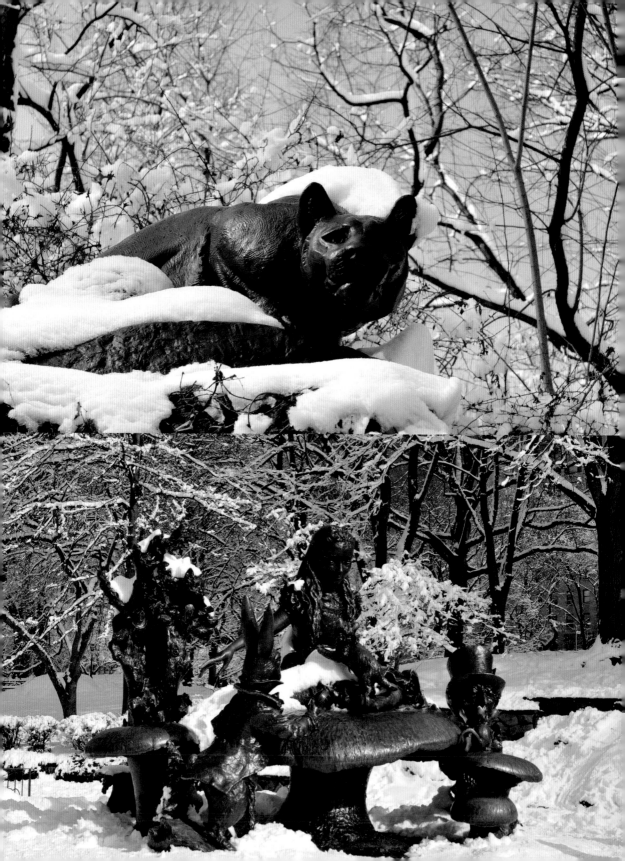

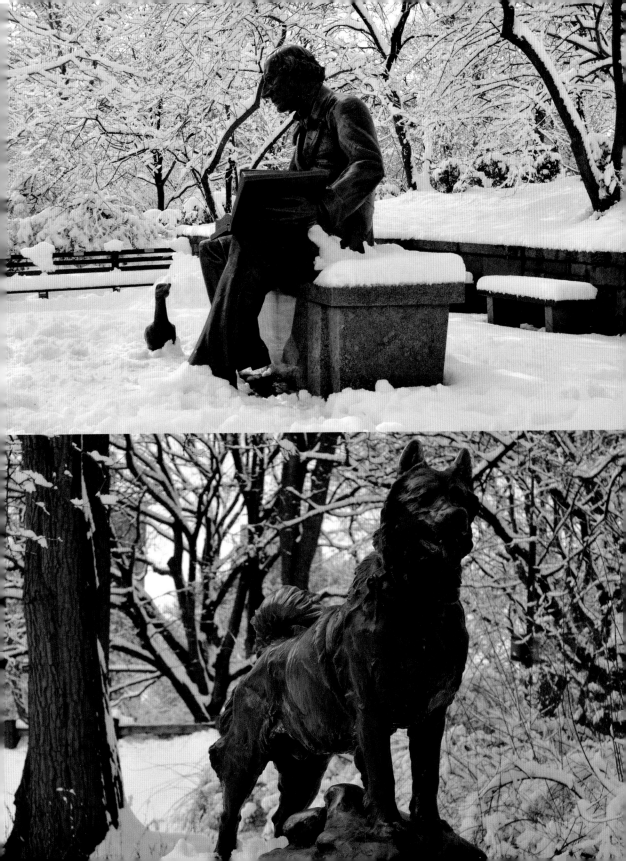

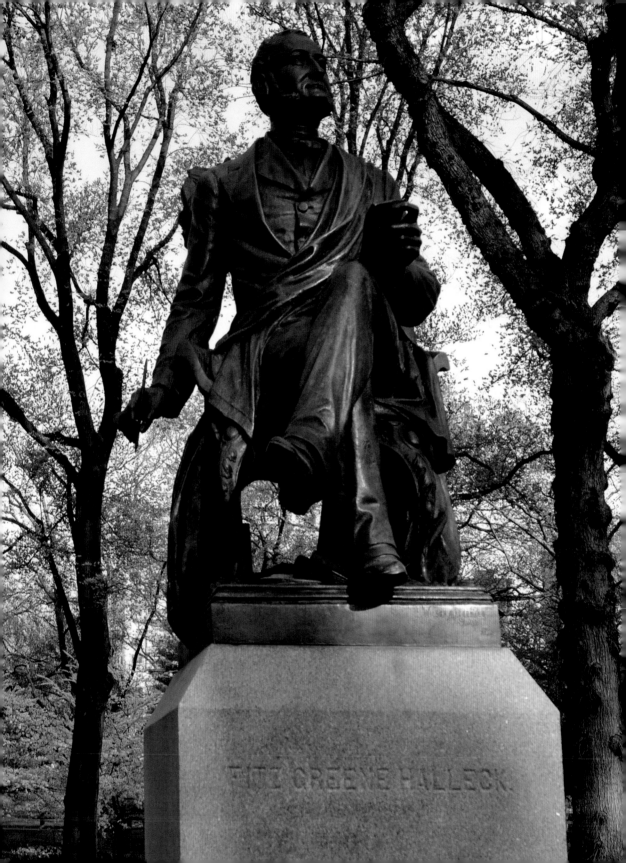

FITZ GREENE HALLECK.

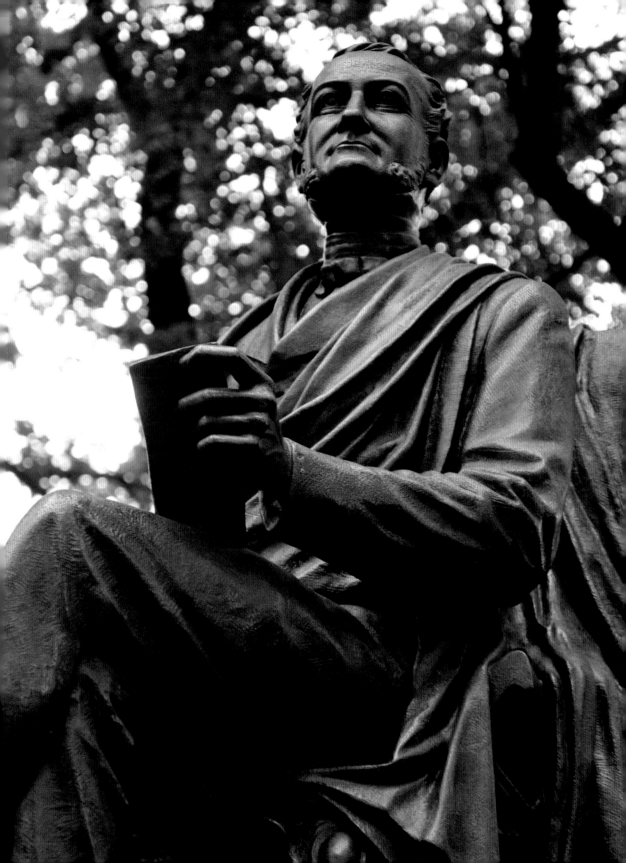

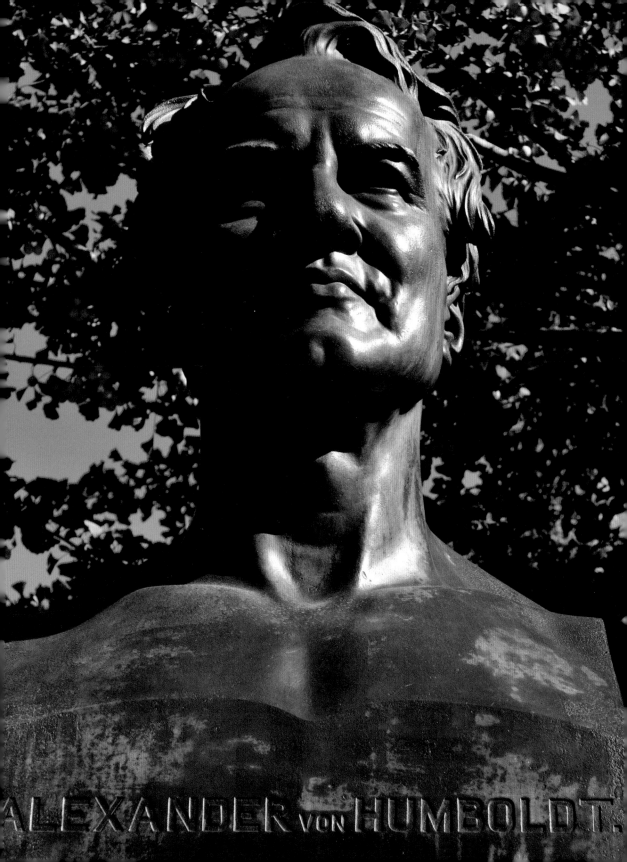

ALEXANDER von HUMBOLDT.

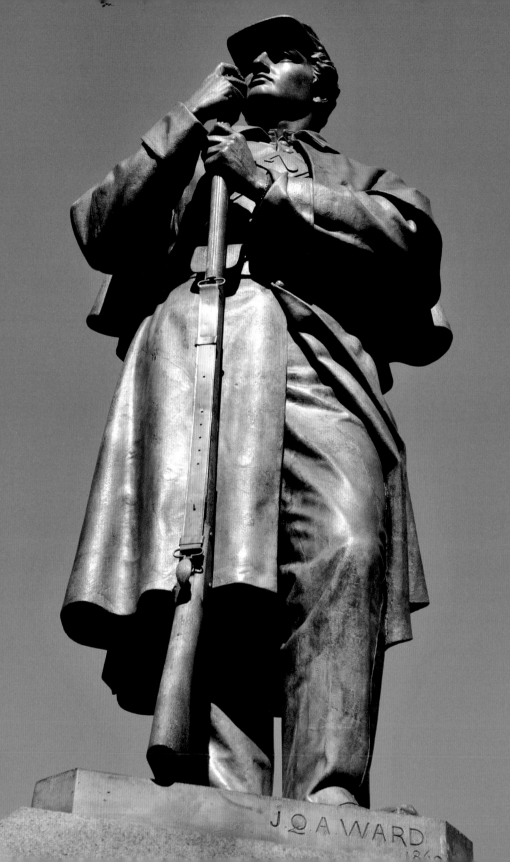

J.Q.A.WARD.
186_

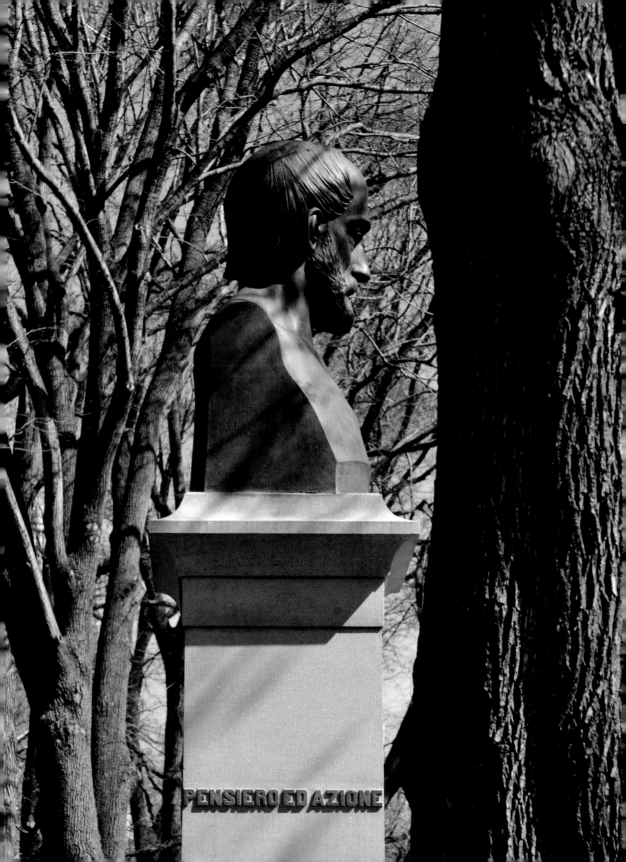

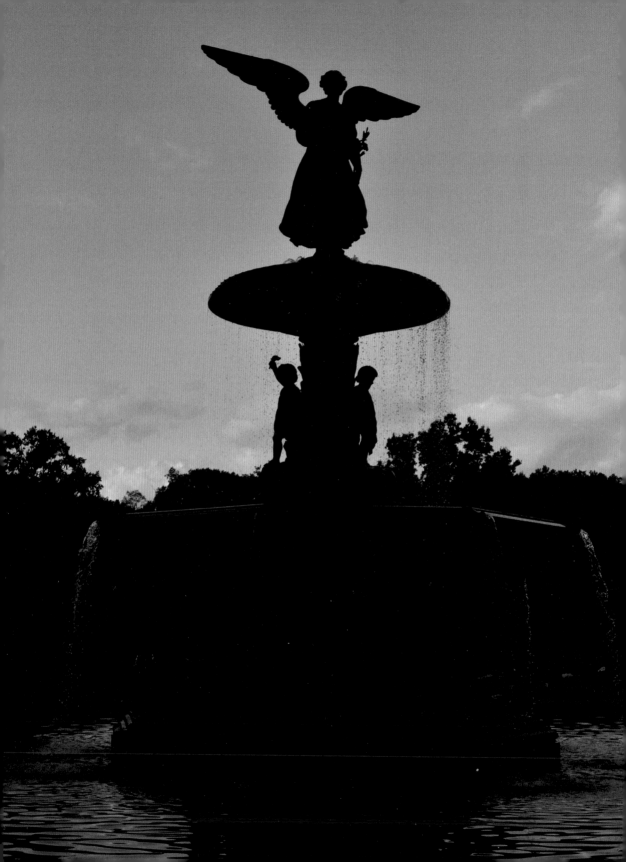

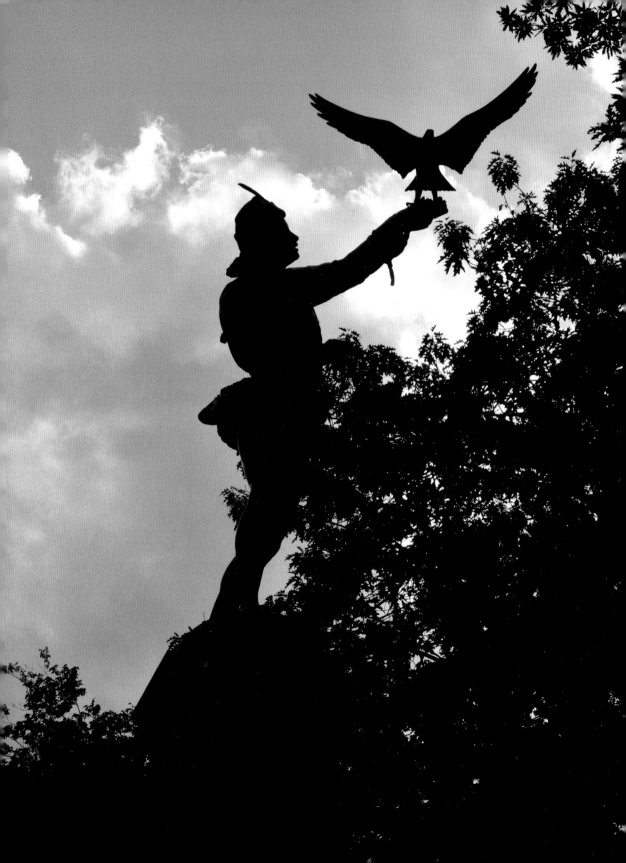

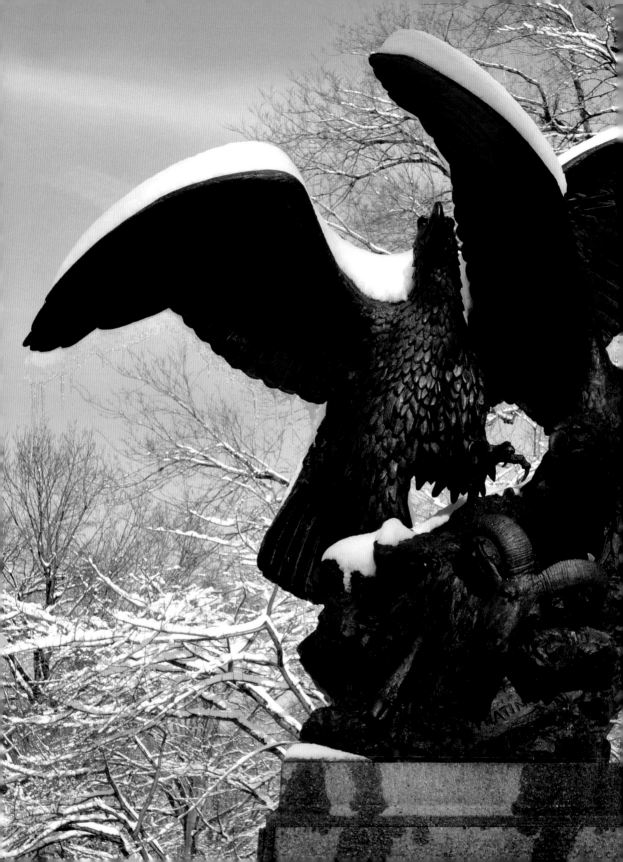

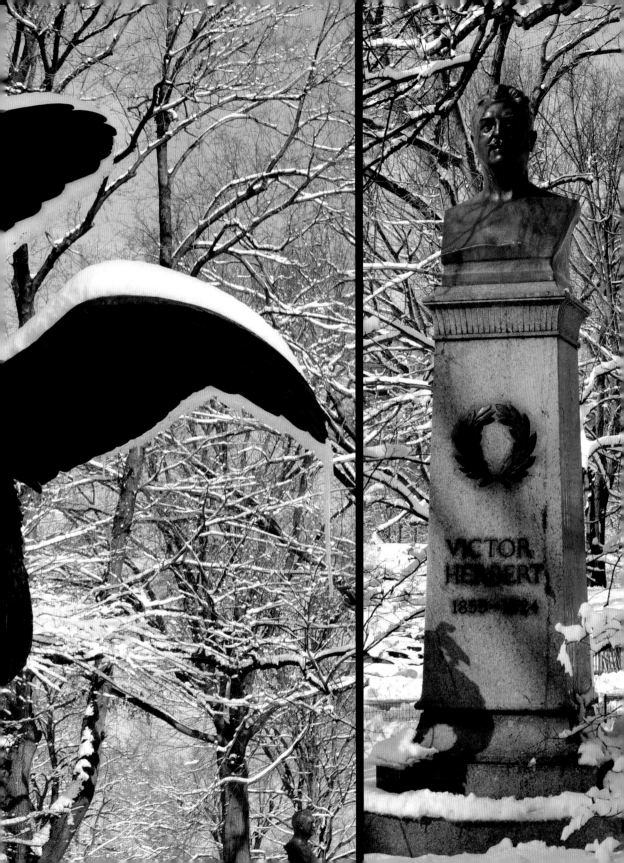

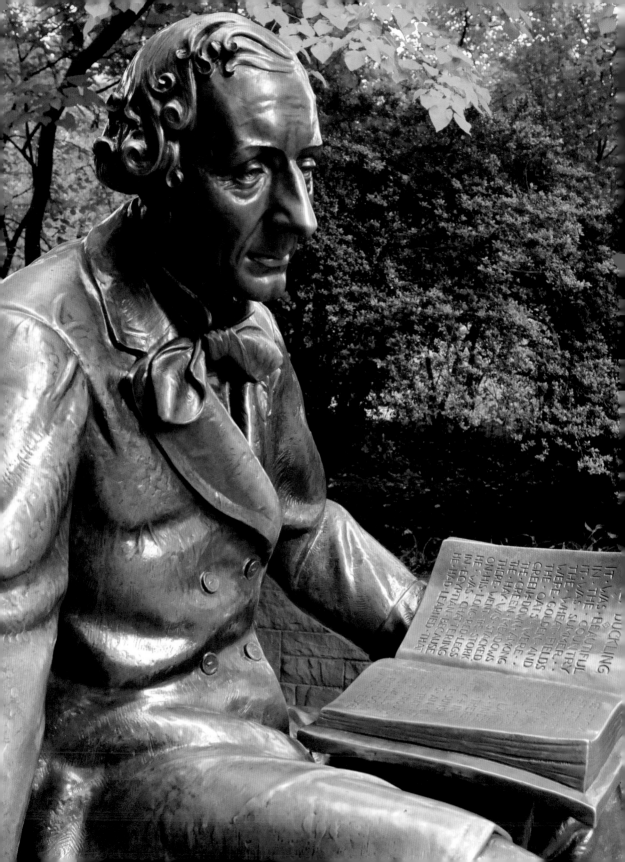

DUCKLING

IT · WAS · BEAUTIFUL
IN · THE · COUNTRY.
IT · WAS · SUMMER.
THE · WHEAT · WERE
THE · OATS · GOLDEN · AND
GREEN · MEADOWS · WERE.
THE · GREEN · AND
HE · HAY · DOWN · ON THE
THERE · WAS · STACKED,
ON · HIS · LONG · MEADOWS
HE · WAS · STORK
IN · EGYPTIAN · LEGS
HE · HAD · LEARNED · BECAUSE
THAT

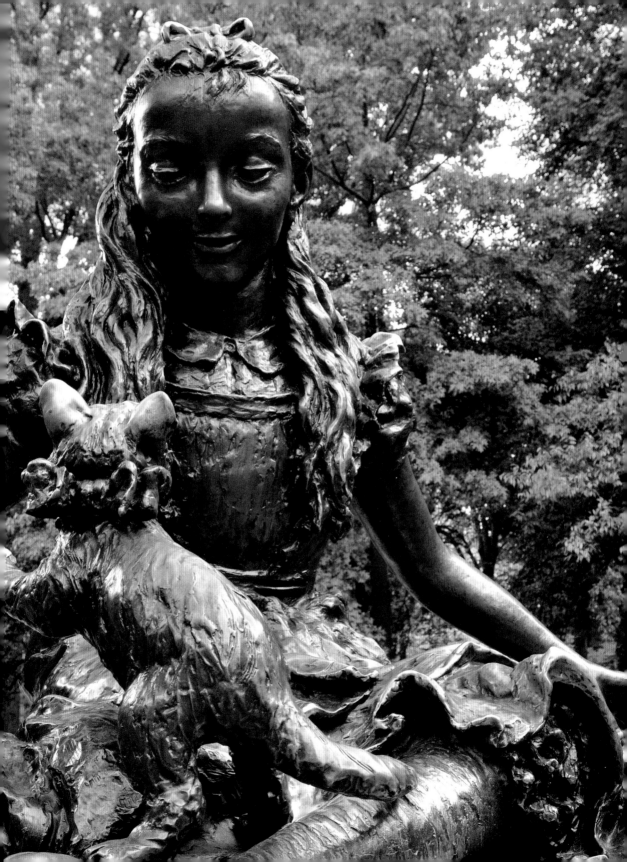

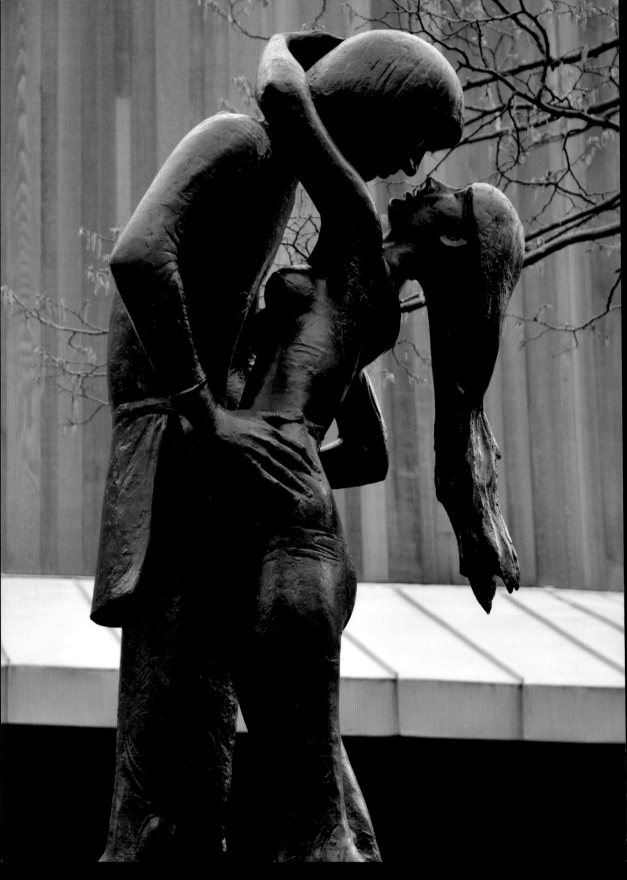

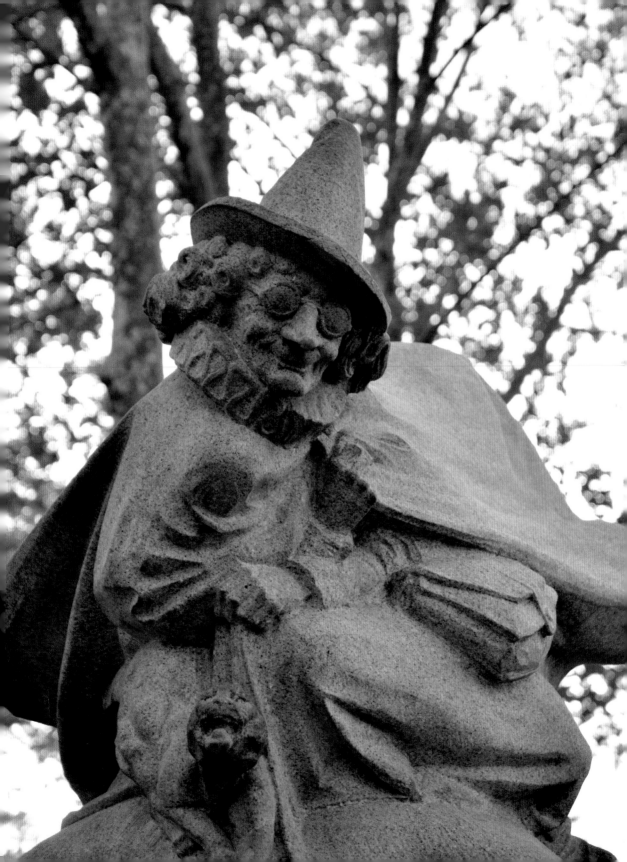

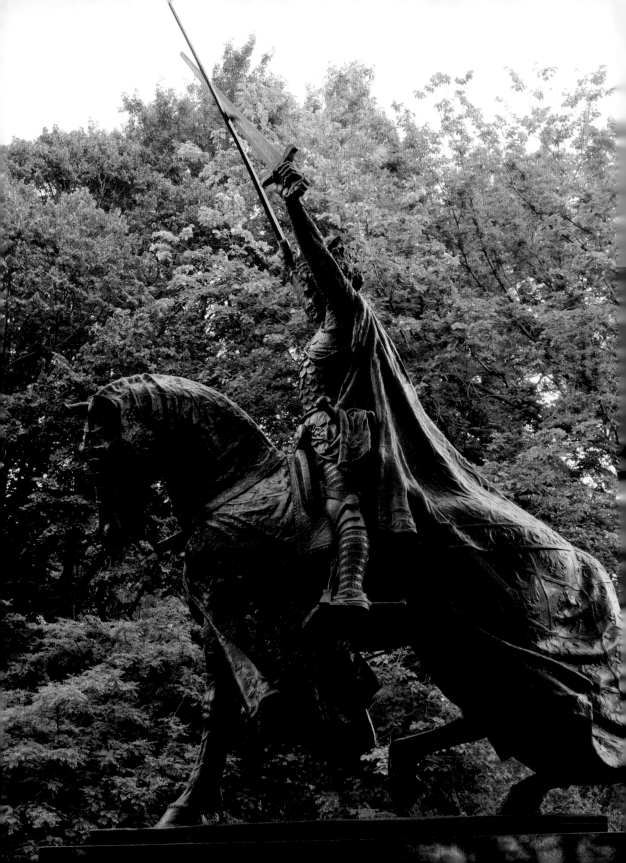

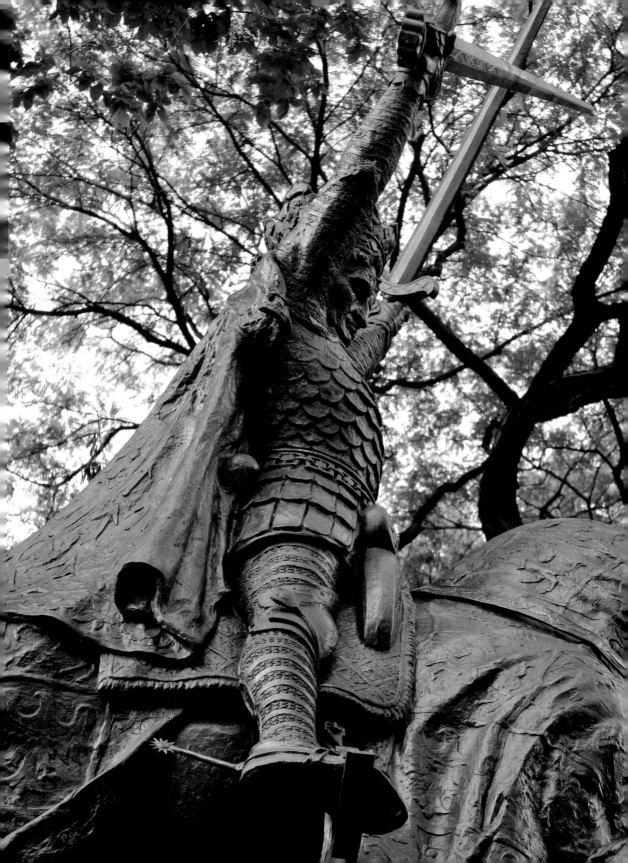

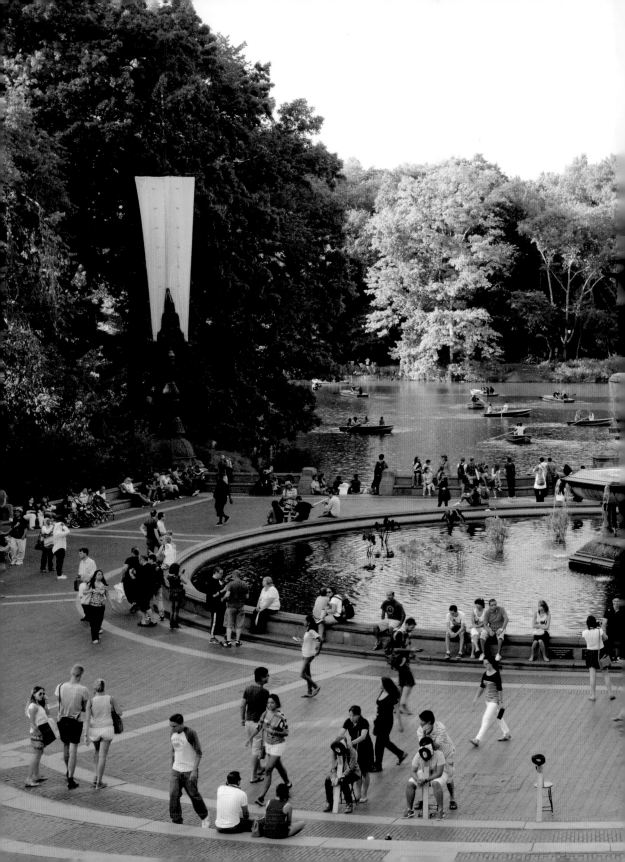

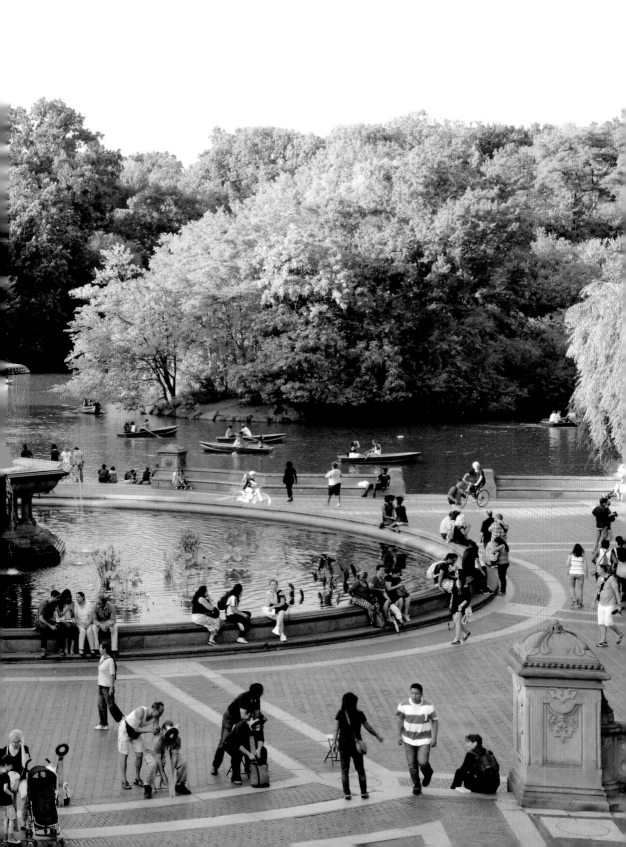

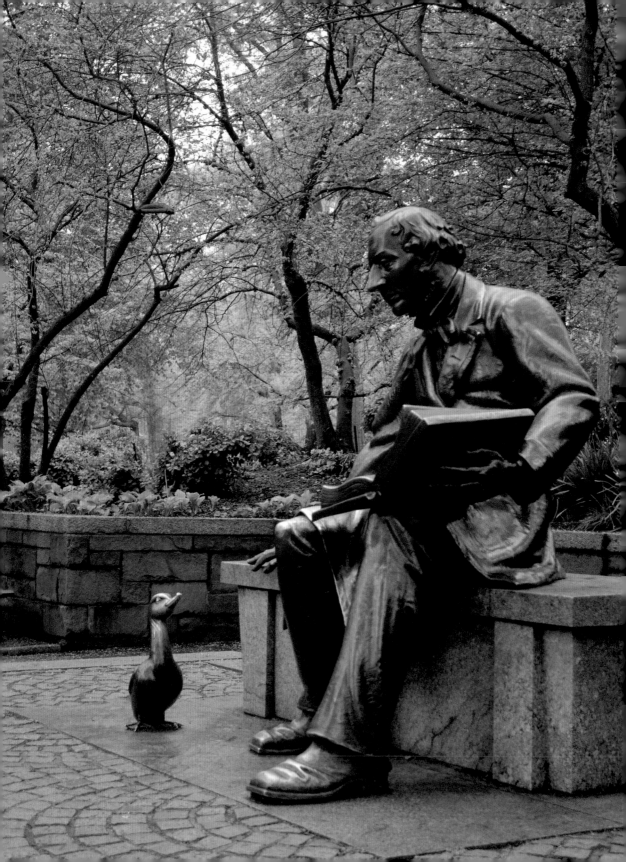

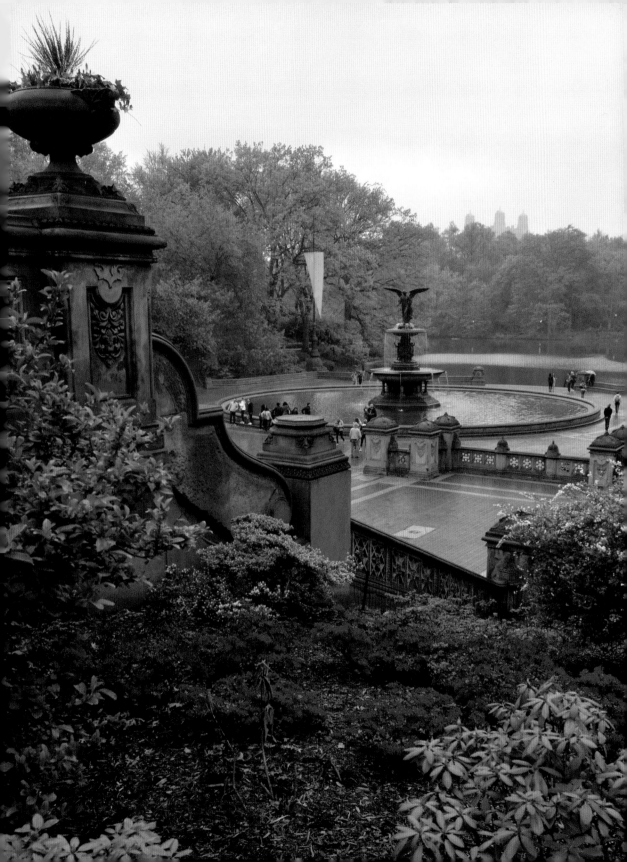

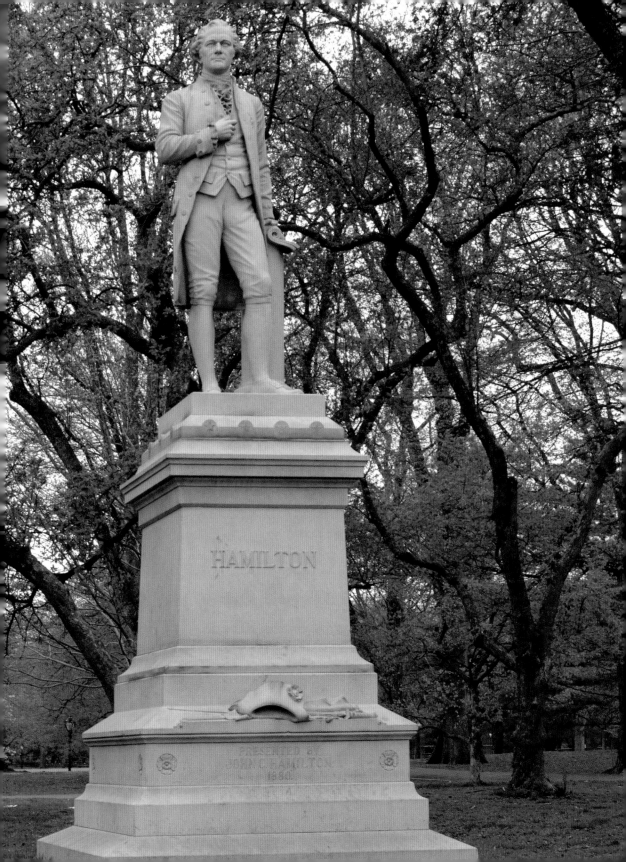

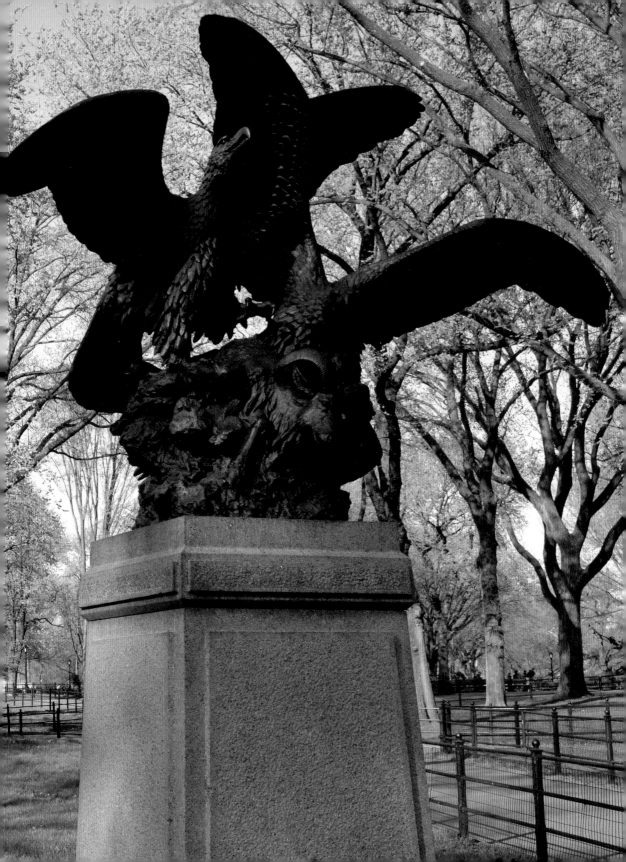

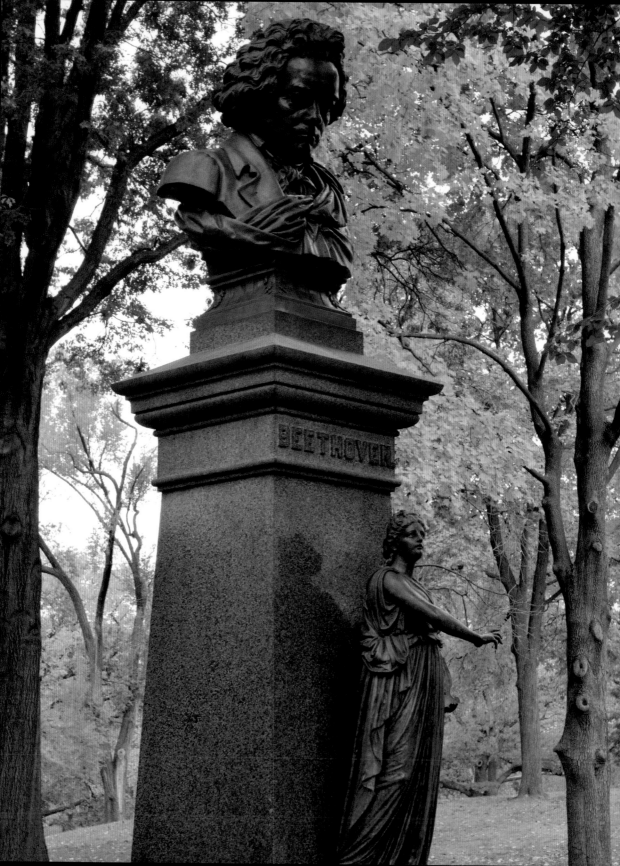

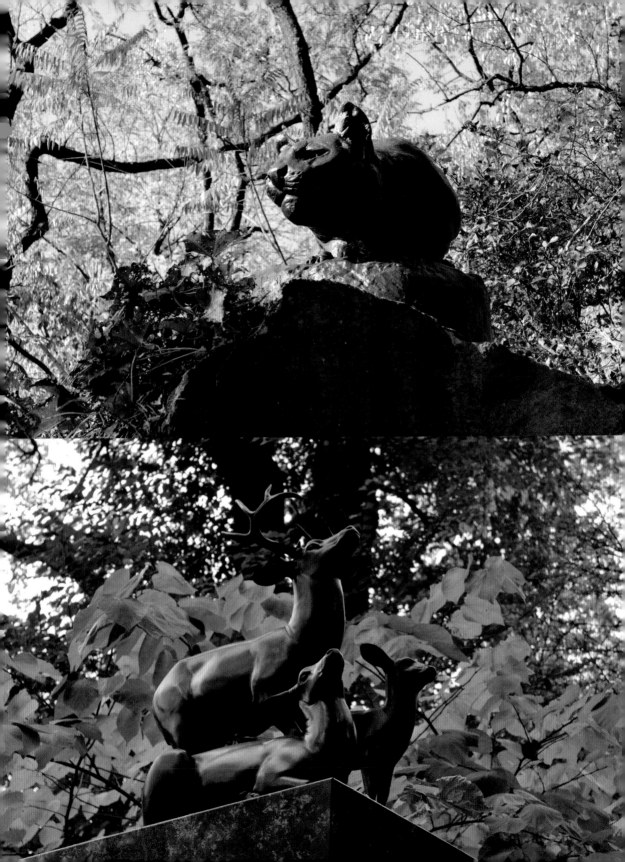

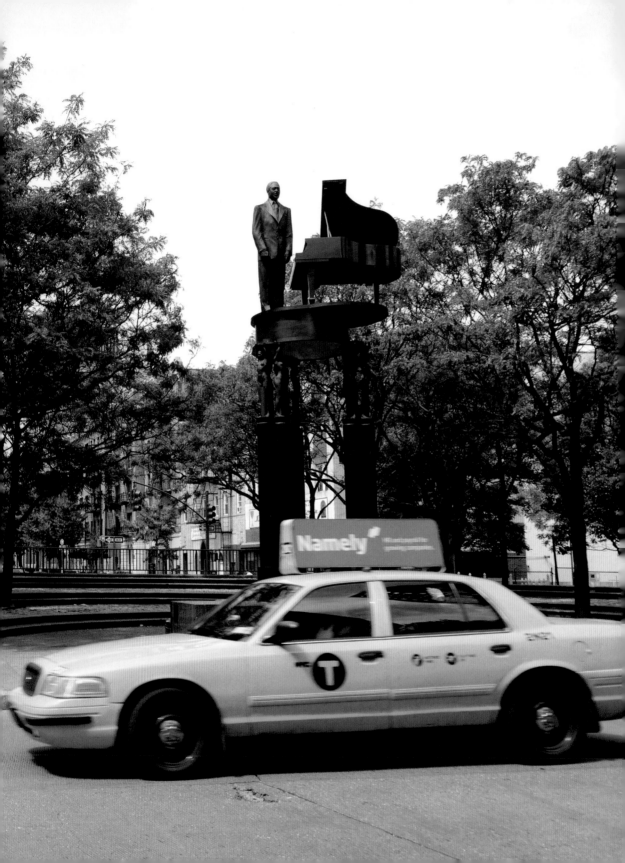

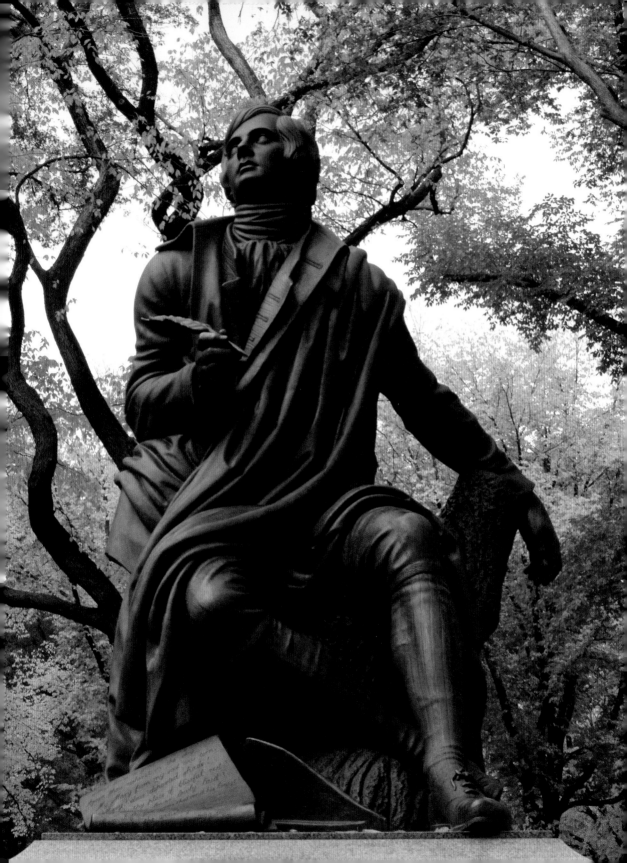

VICTOR
HERBERT
1859–1924

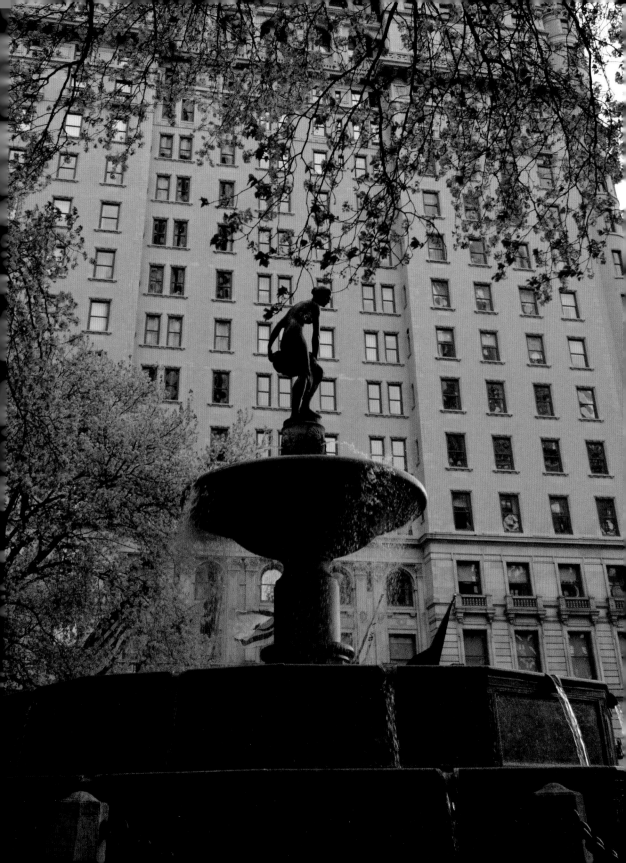

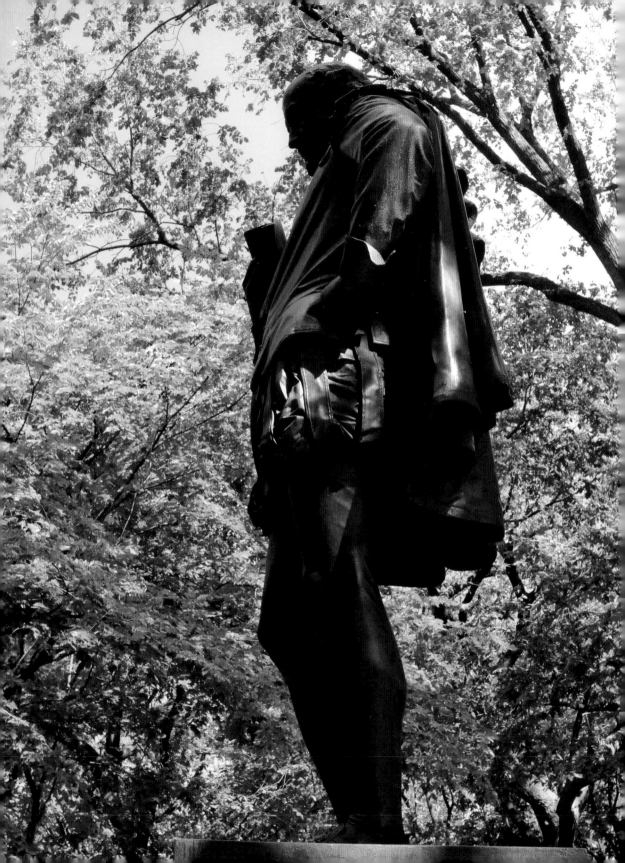

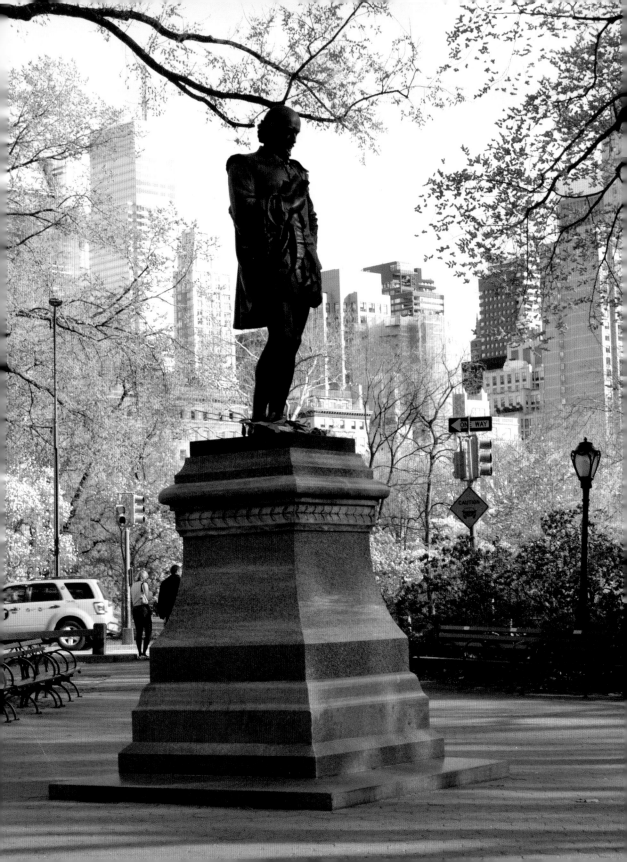

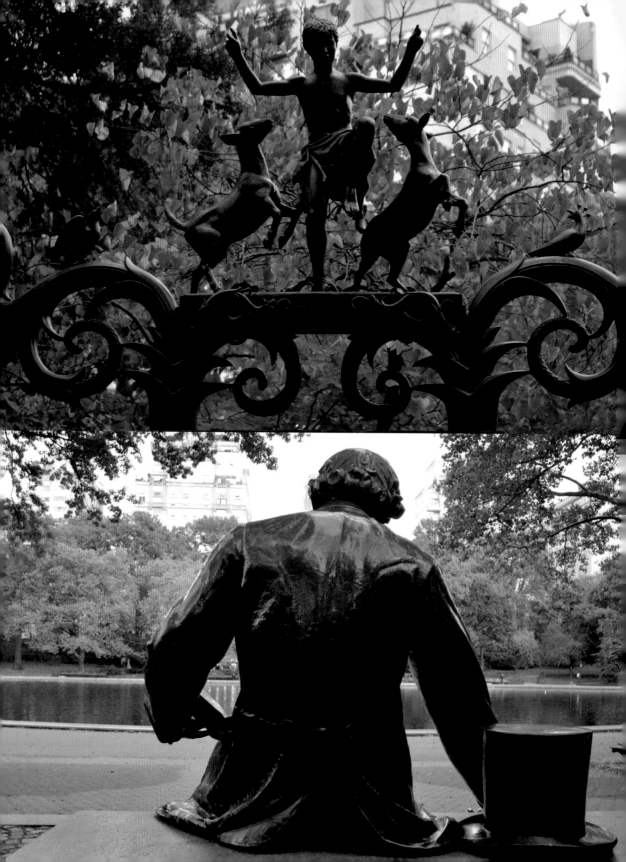

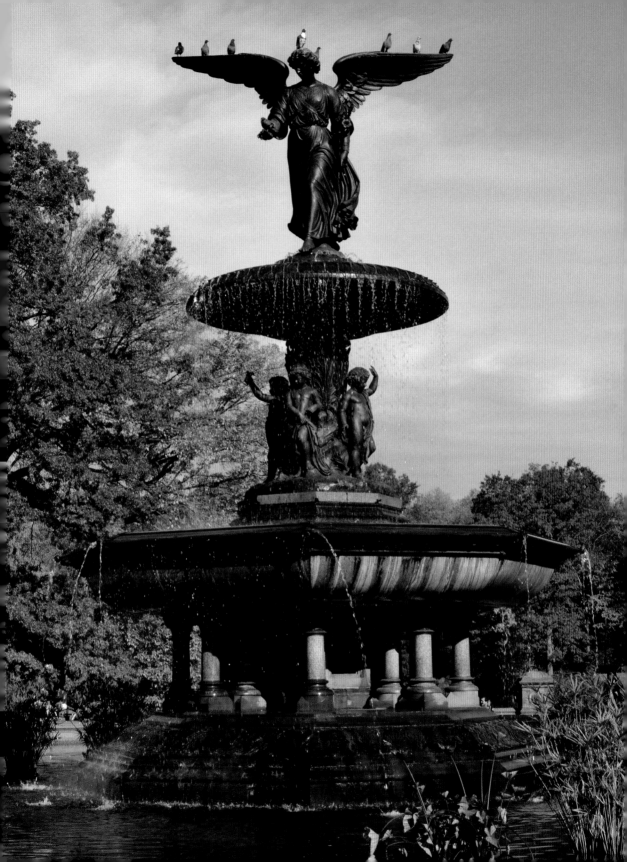

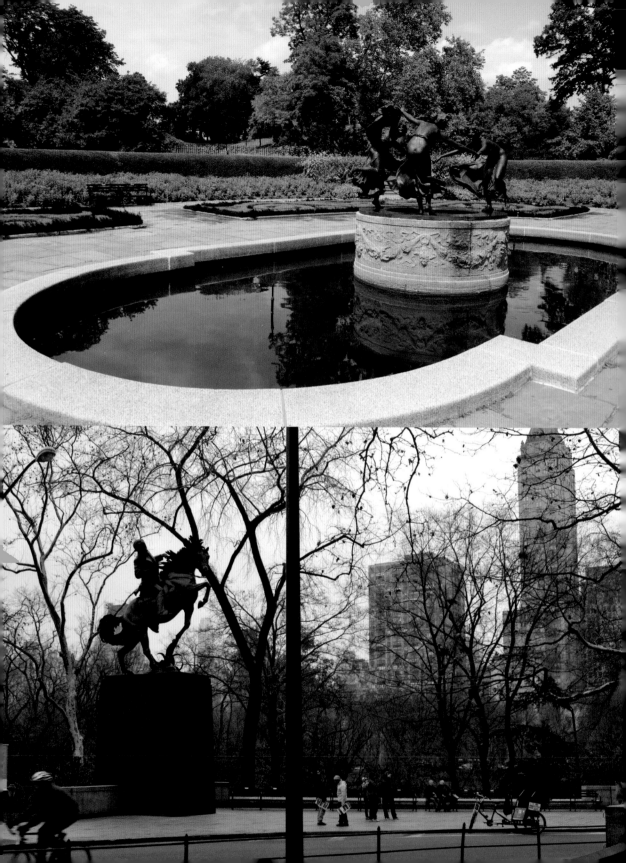

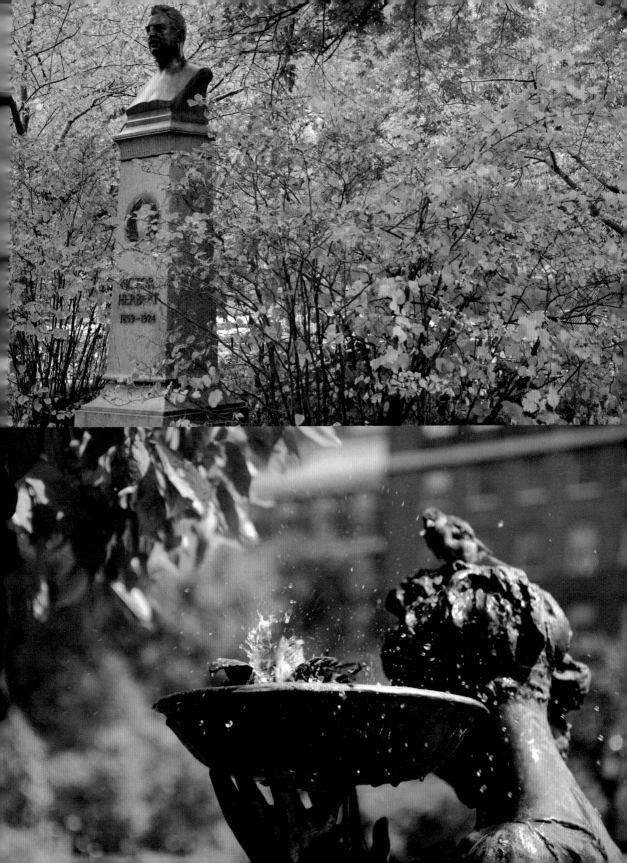

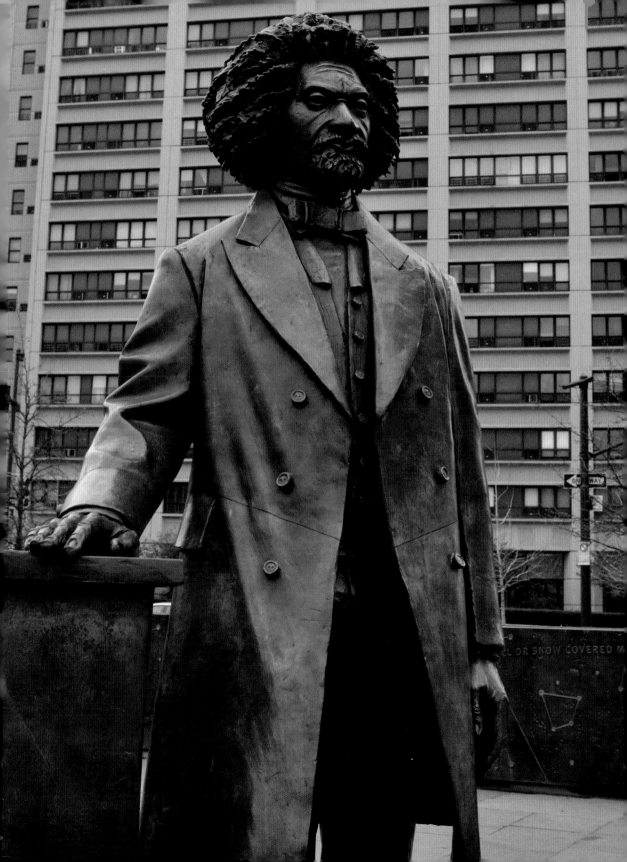

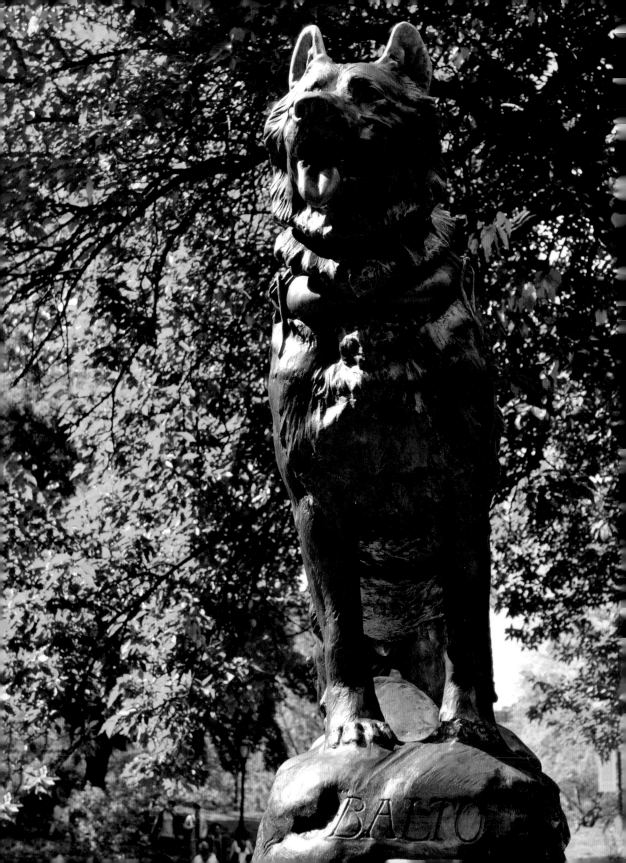

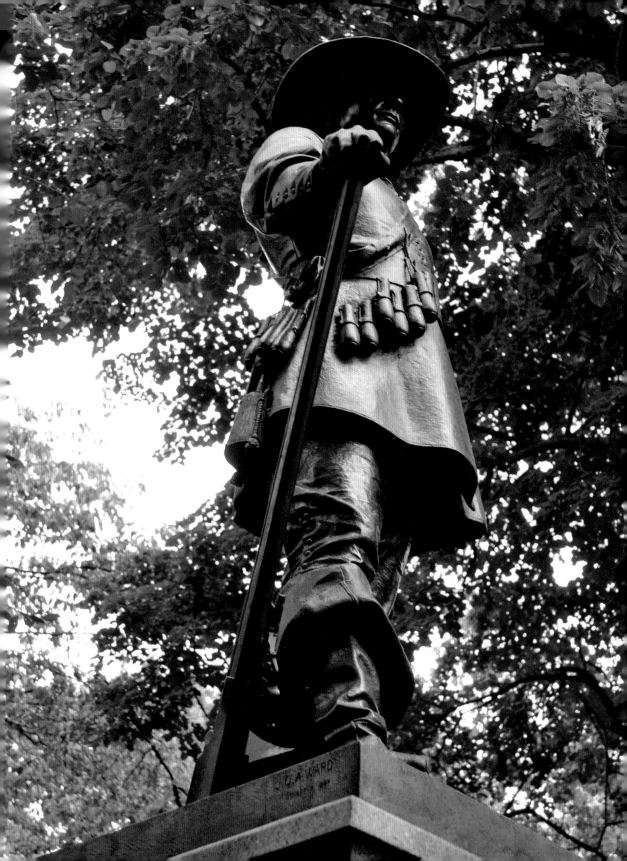

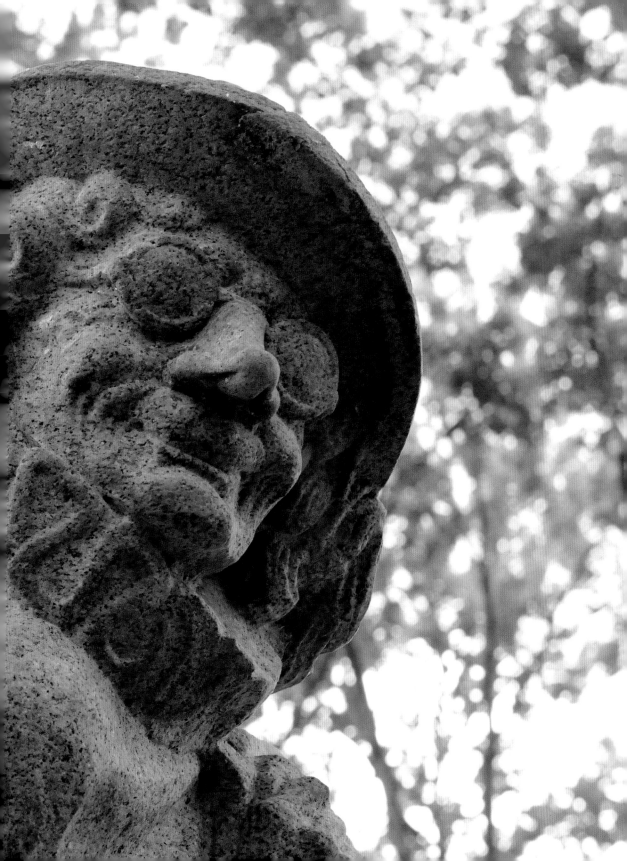

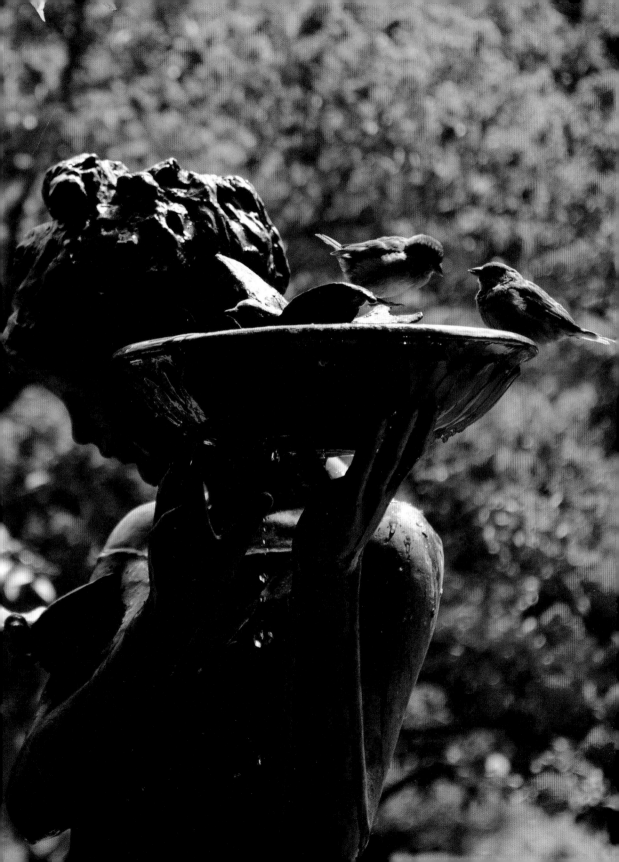

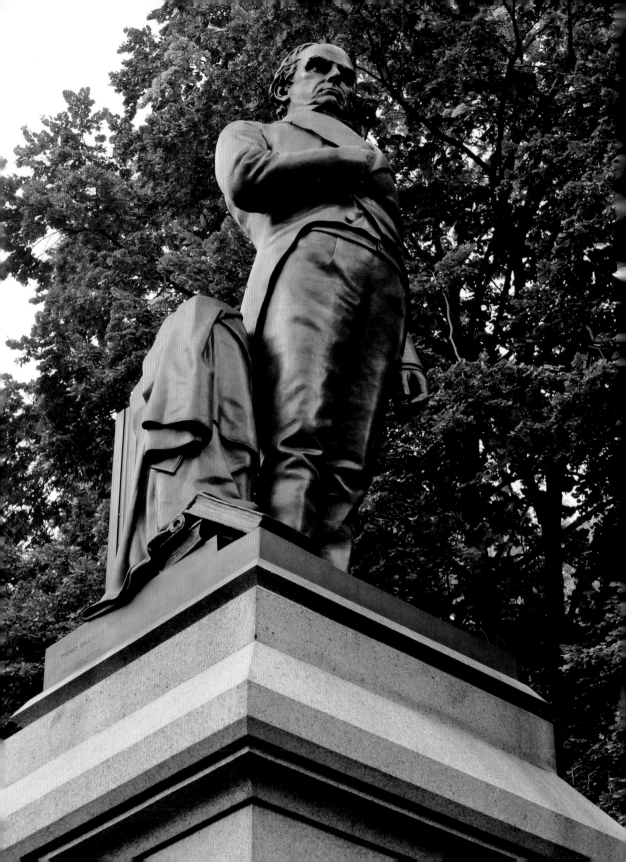

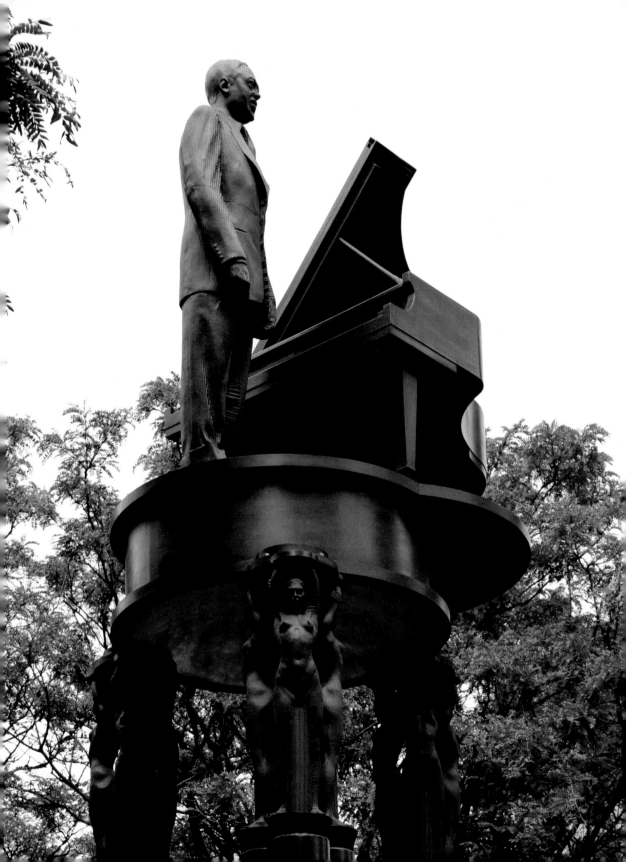

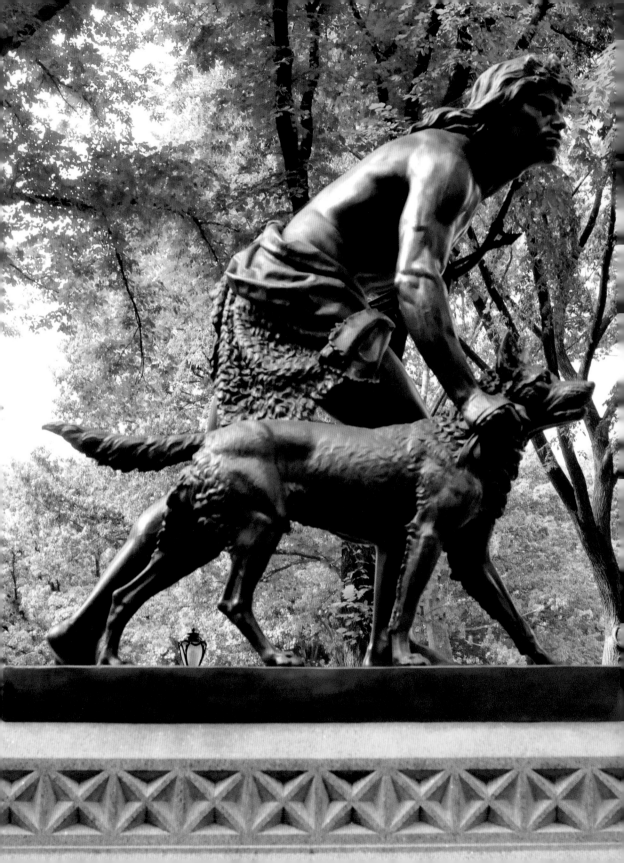

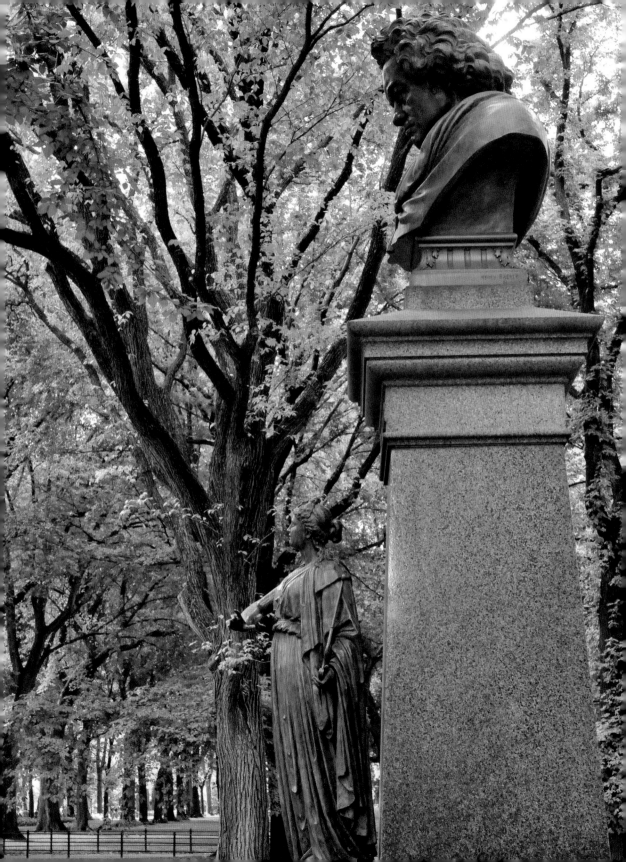

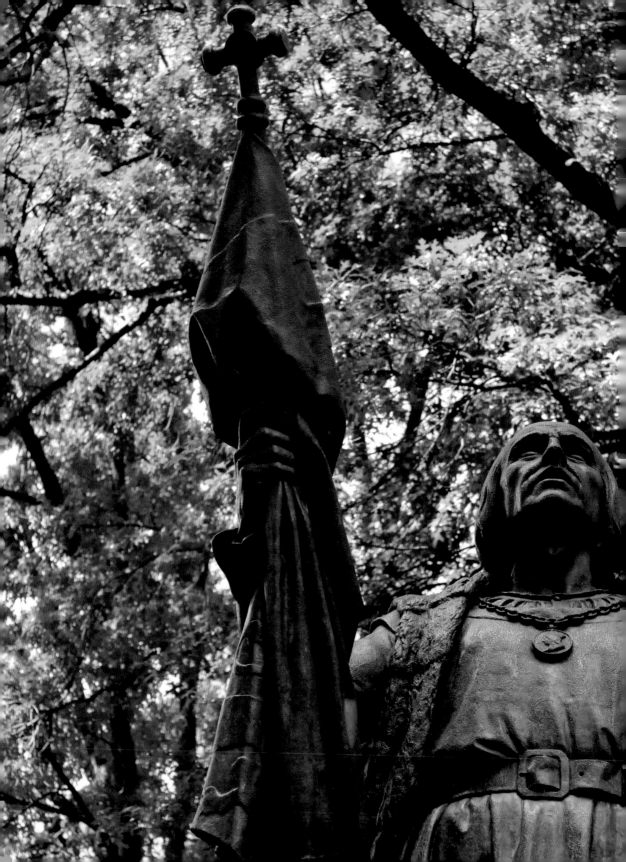

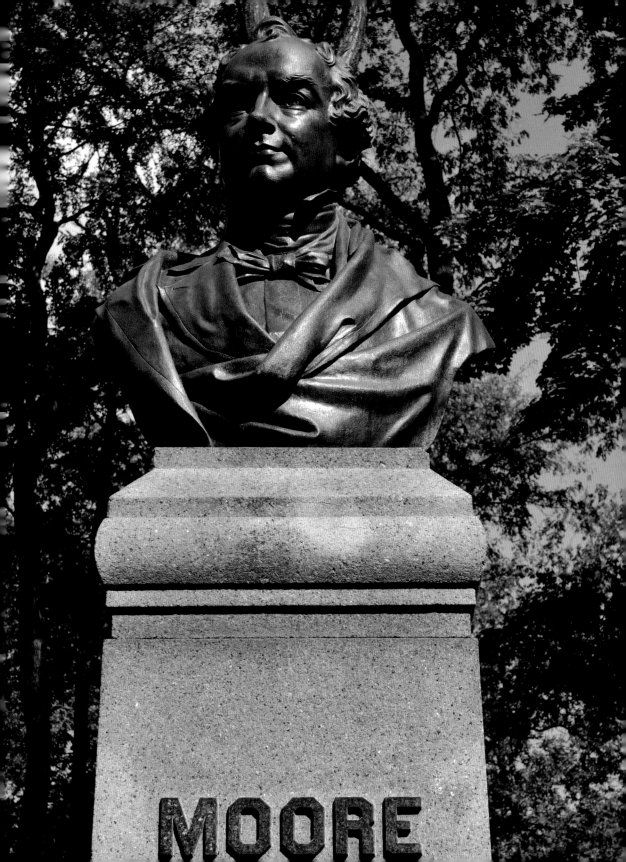

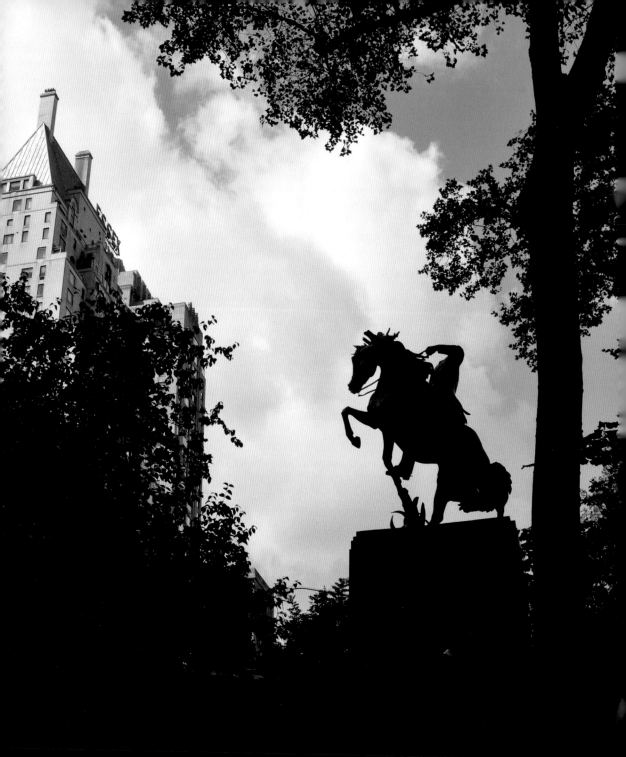

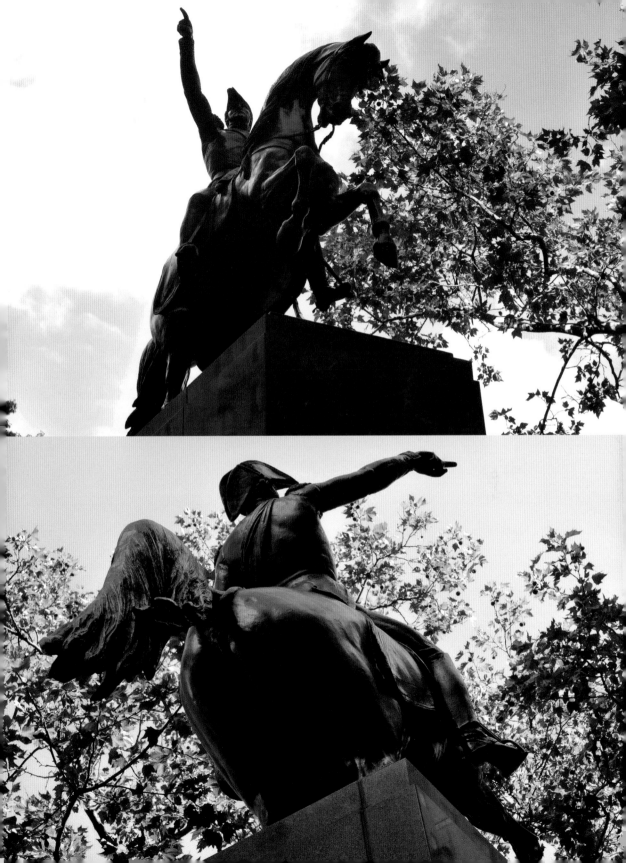

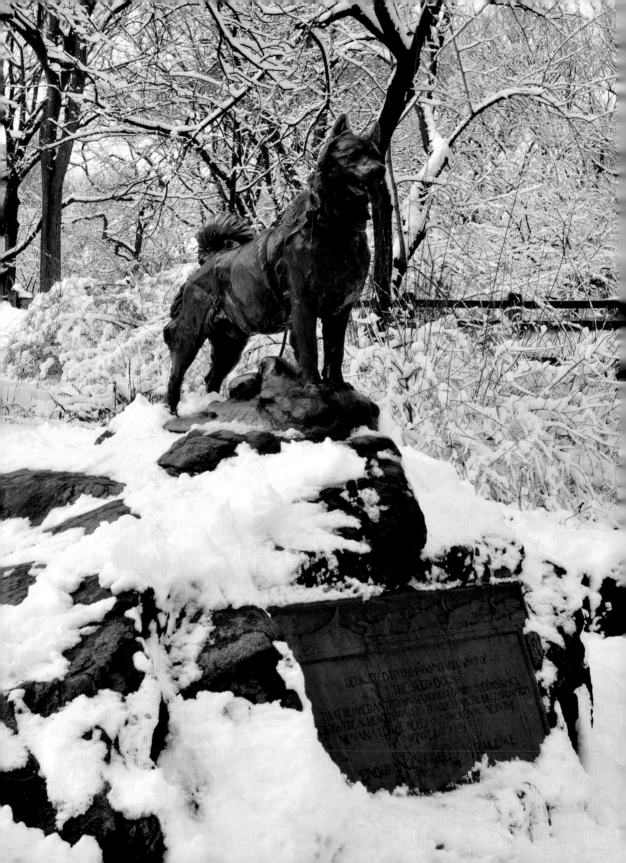

DEDICATED TO THE INDOMITABLE SPIRIT OF
THE SLED DOGS
THAT RELAYED ANTITOXIN SIX HUNDRED MILES OVER ROUGH ICE
ACROSS TREACHEROUS WATERS THROUGH ARCTIC BLIZZARDS FROM
NENANA TO THE RELIEF OF STRICKEN NOME IN THE
WINTER OF 1925

ENDURANCE · FIDELITY · INTELLIGENCE

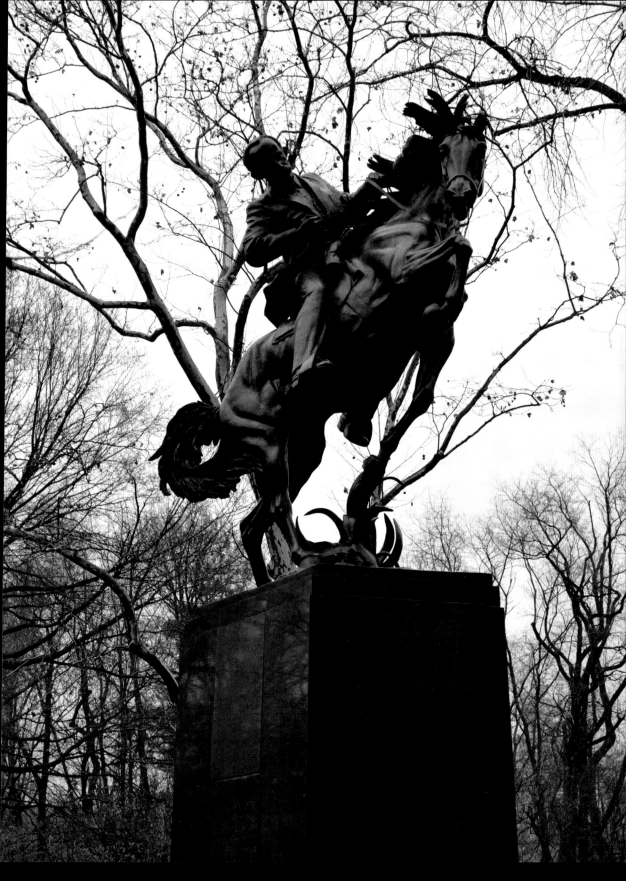

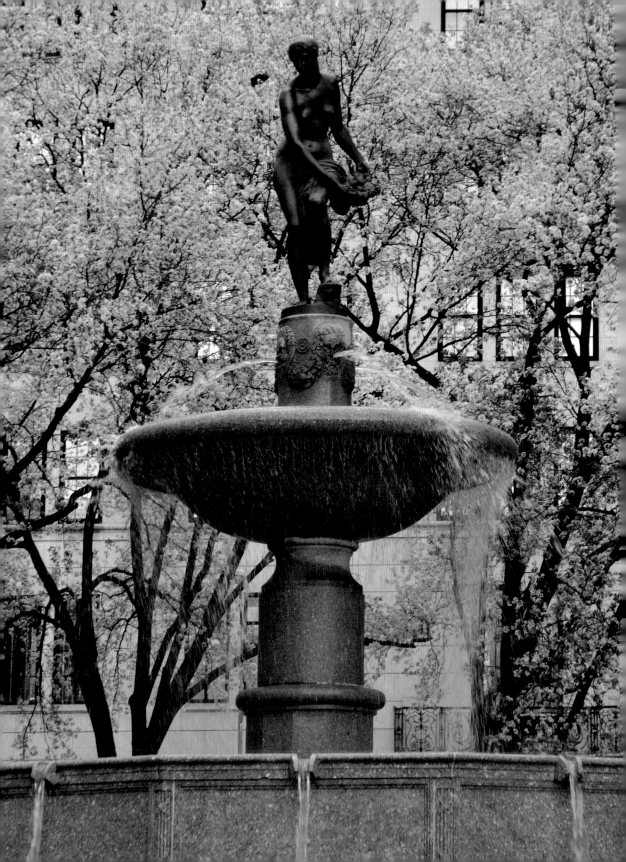

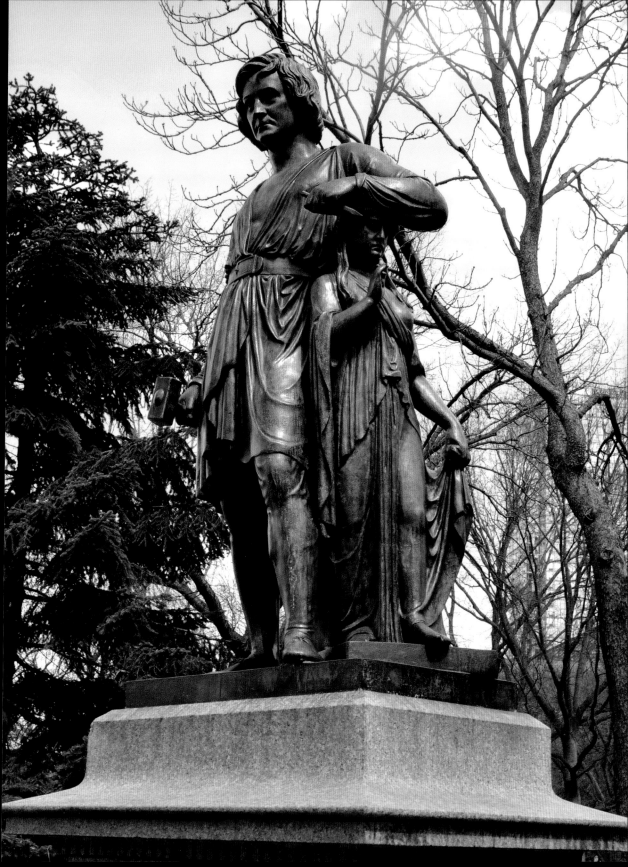

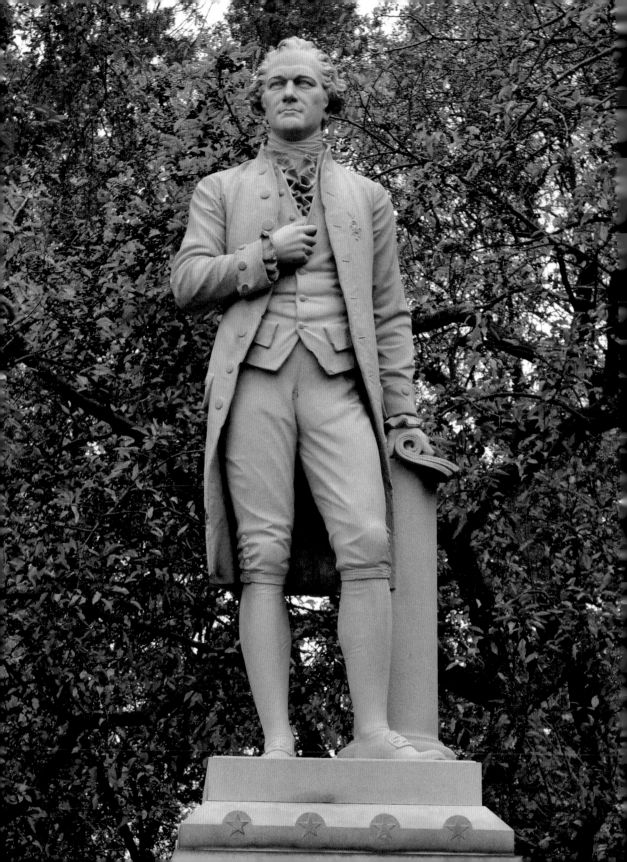

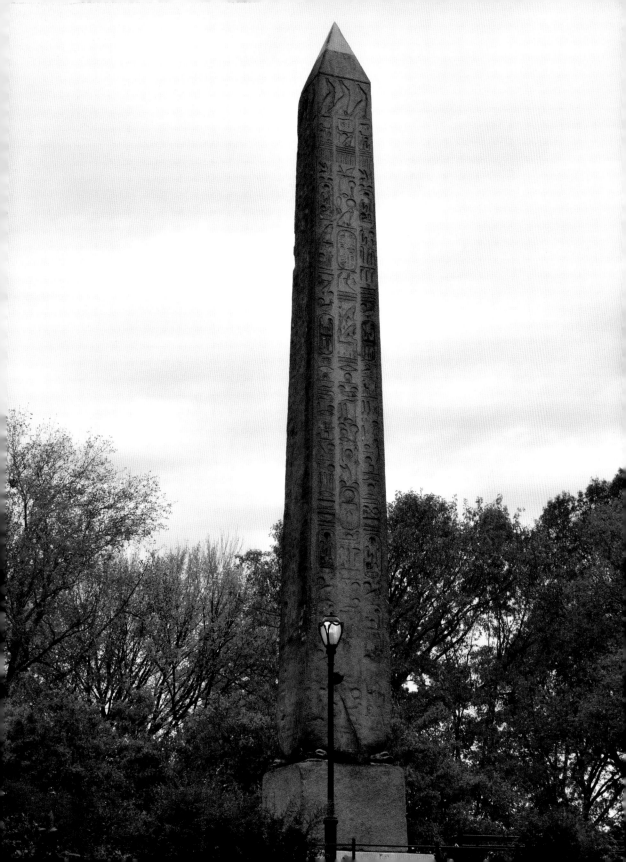

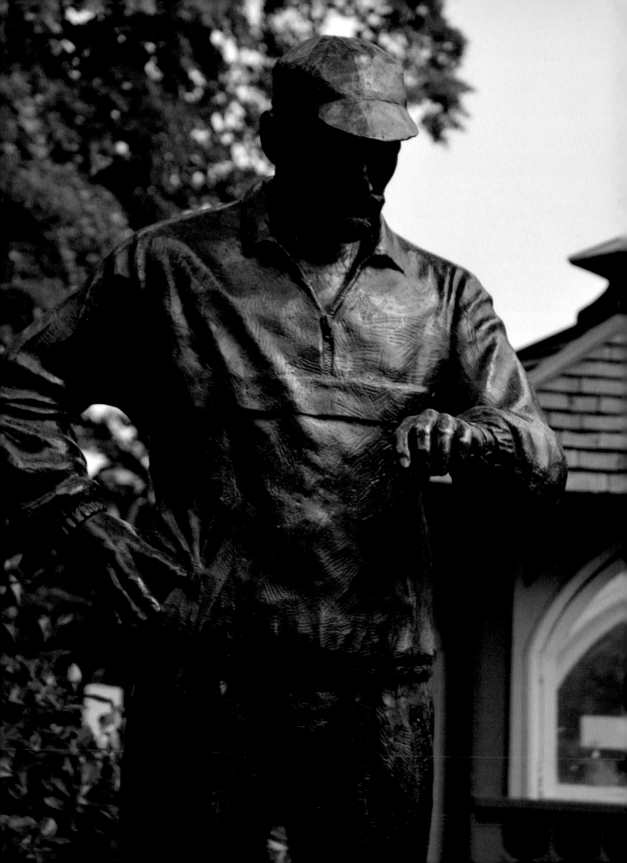

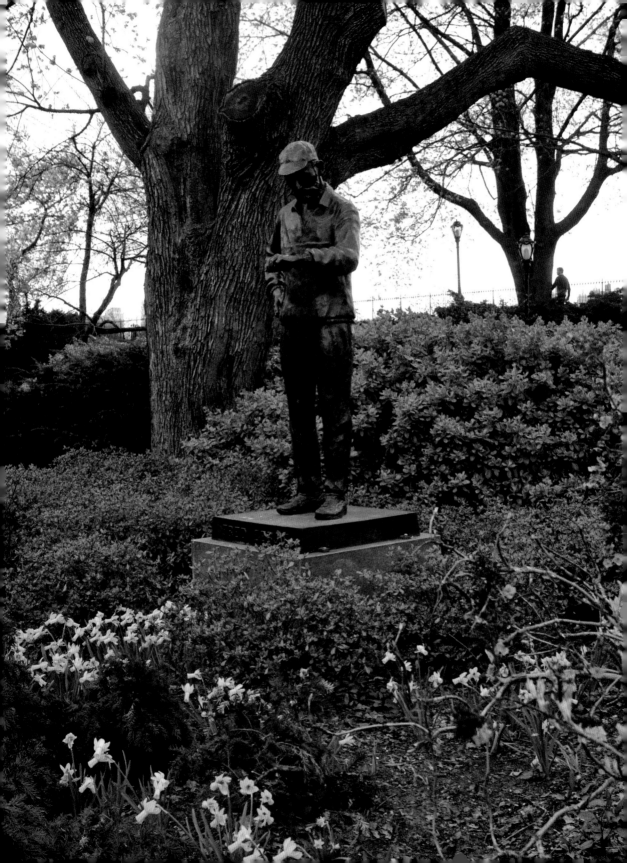

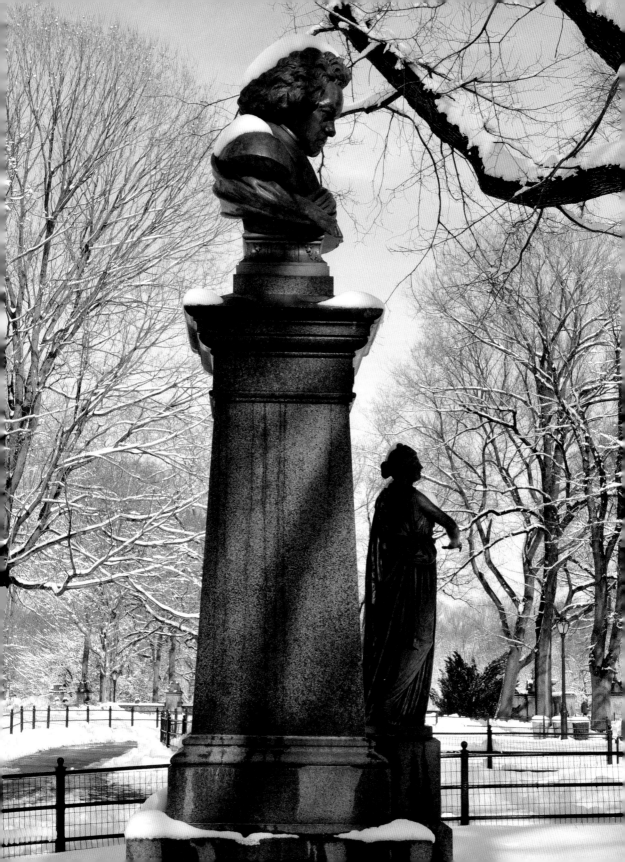

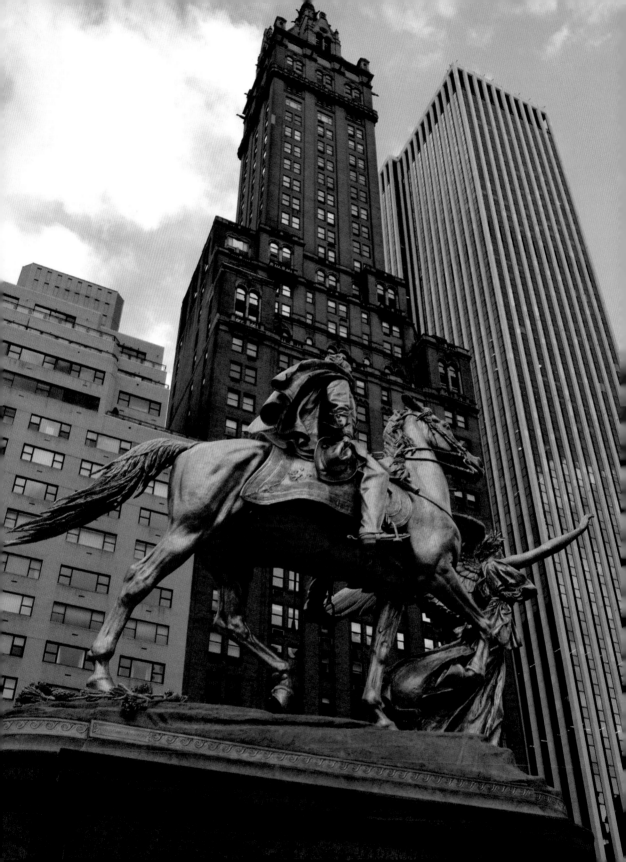

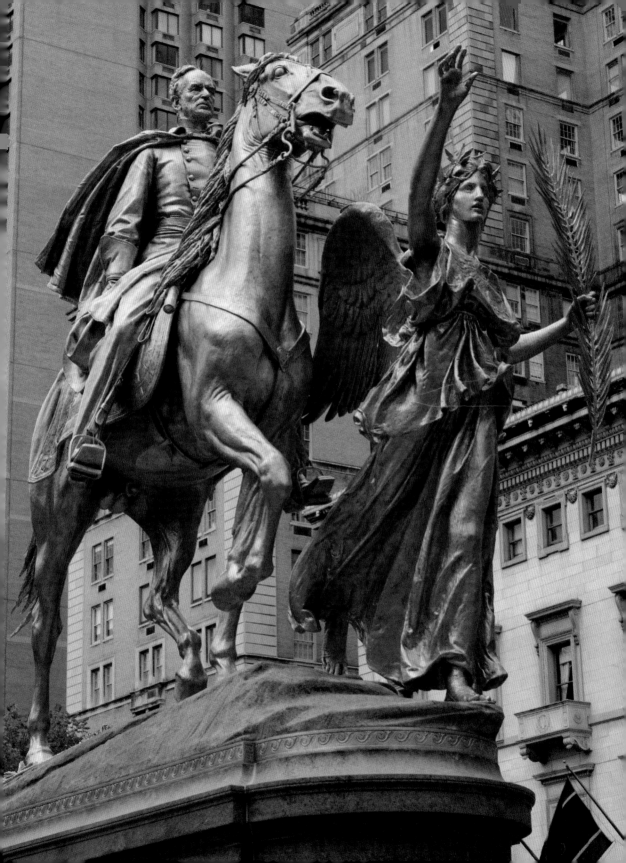

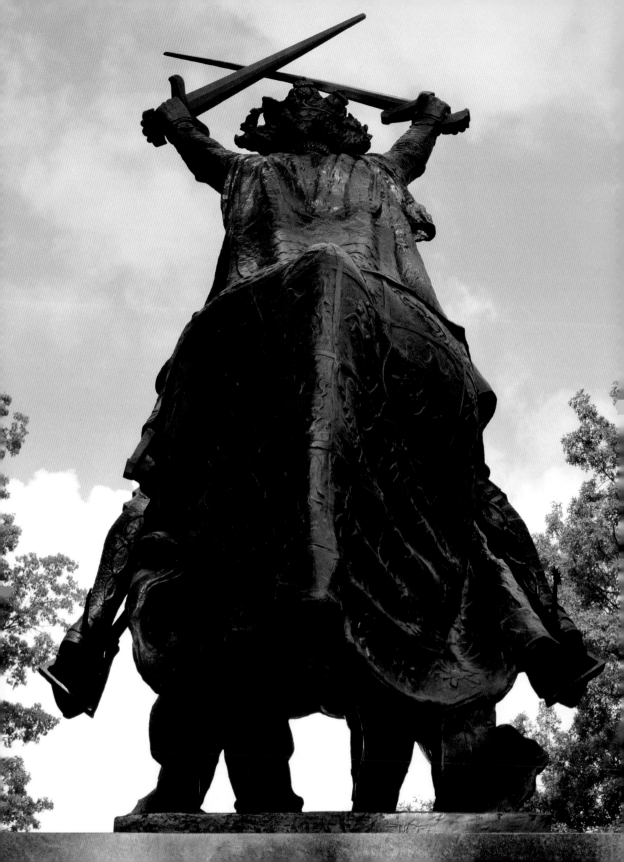

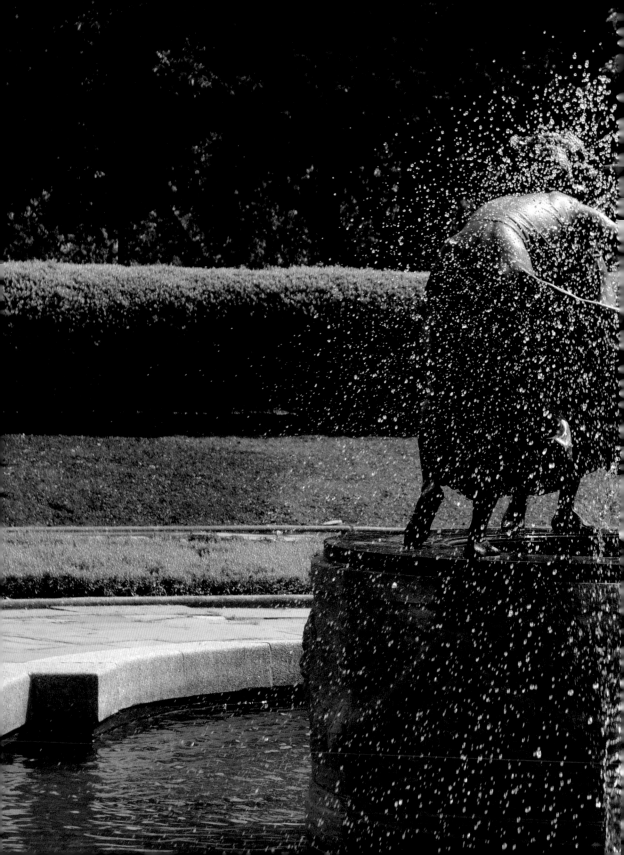

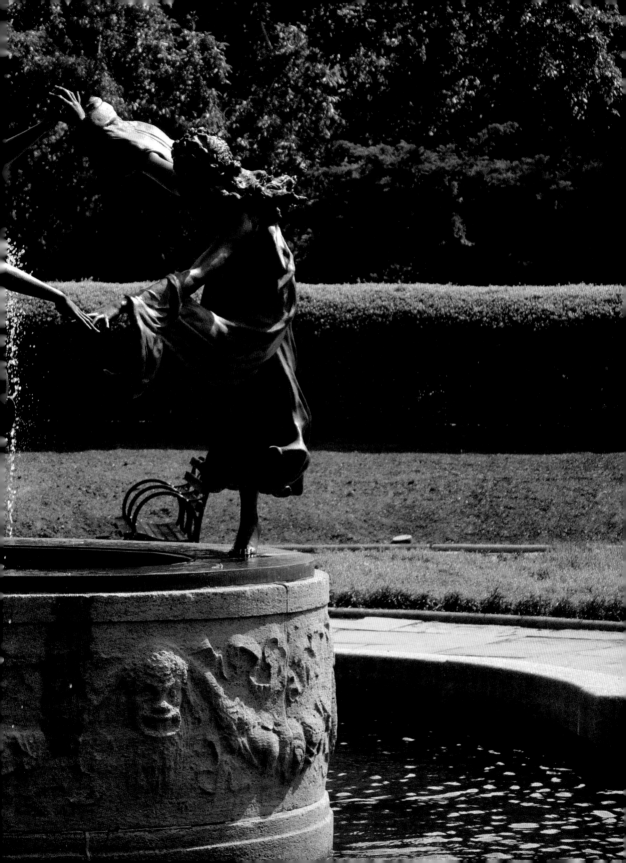

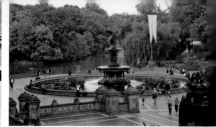

STATUES

Albert Bertel Thorvaldsen 88

Alexander Hamilton 91

Alexander von Humboldt 92

Alice in Wonderland 95

Balto 96

Bethesda Fountain 98

Burnett Memorial Fountain 101

Christopher Columbus 102

Dancing Goat 105

Daniel Webster 106

Duke Ellington Memorial 109

Eagles and Prey 110

The Falconer 113

Fitz-Greene Halleck 114

Fred Lebow 117

Frederick Douglass 118

Giuseppe Mazzini 121

Hans Christian Andersen 122

Honey Bear 105

Indian Hunter 125

Johann Christoph Friedrich
von Schiller 128

John Purroy Mitchel 131

José de San Martín 132

José Julián Martí 135

King Jagiello 126

Lehman Gates 136

Ludwig van Beethoven 139

Mother Goose 140

The Obelisk 143

One Hundred Seventh
Infantry Memorial 87

The Pilgrim 145

Pulitzer Fountain 146

Richard Morris Hunt 149

Robert Burns 150

Romeo and Juliet 153

Samuel F. B. Morse 154

Simón Bolívar 157

Sophie Loeb Memorial Fountain 158

Still Hunt 161

The Tempest 153

Thomas Moore 162

Untermeyer Fountain 164

USS Maine Monument 165

Victor Herbert 167

Sir Walter Scott 168

William Church Osborn Gates 170

William Shakespeare 173

William Tecumseh Sherman 174

William T. Stead Memorial 177

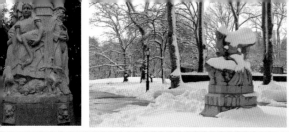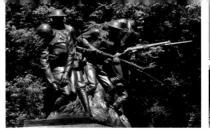

PART THREE
THE HISTORY
BEHIND THE ART

❧

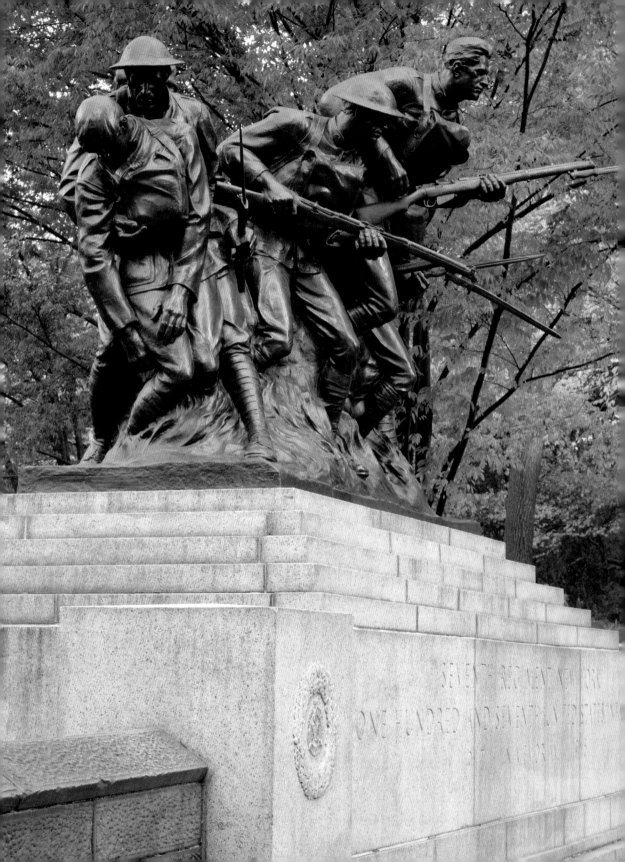

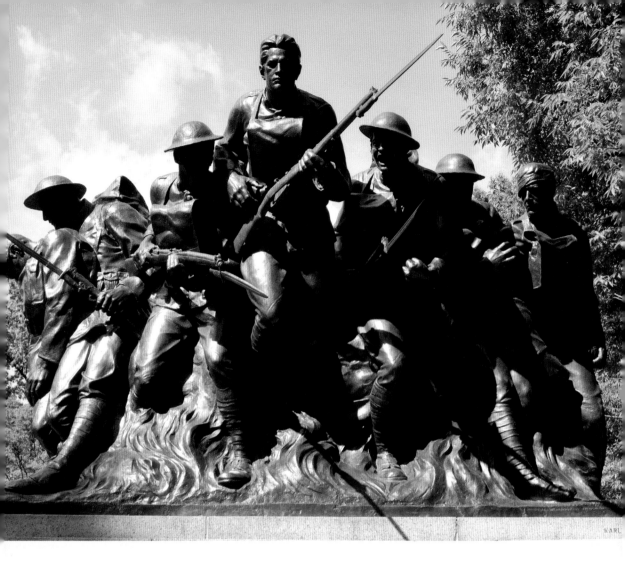

One Hundred Seventh Infantry Memorial

East 67th Street and Fifth Avenue

Dedicated in 1927, these dynamic, larger-than-life figures by artist Karl Illava honor the soldiers who served in World War I. The artist, who served in the 107th Infantry, used his own hands as models for the soldiers'.

Albert Bertel Thorvaldsen

97th Street Transverse

AT FIRST GLANCE, THIS IMPOSING, LIFE-SIZED SCULPTURE elevated on a block of Danish granite is enigmatic: a man in a toga clutches a hammer in one hand and rests his other arm on the head of a female figure. In fact, this is a self-portrait carved by the artist himself, Albert Bertel Thorvaldsen, and it is the only sculpture of an artist in all of Central Park.

Although he may be unfamiliar to most, Thorvaldsen was a prolific artist in the Neoclassical style who was internationally famous during his lifetime. Thorvaldsen was accepted to the Royal Danish Academy of Art when he was only eleven and went on to create more than 90 sculptures and over 150 busts, in addition to hundreds of reliefs in marble and stone, for patrons all over Europe. He lived and worked for many years in Rome, Italy, and has the unique distinction of being the only non-Italian to have created a sculpture in St. Peter's Basilica in Rome—the tomb/monument of Pope Pius VII.

In his sculptural self-portrait, Thorvaldsen depicts himself at work, wearing a workman's outfit and holding a sculptor's chisel and mallet. The figure upon which he rests his other hand is one of his own creations, a sculpture of the figure of Hope.

The bronze replica in the Park is based on the original marble sculpture in the Thorvaldsen Museum in Copenhagen, Denmark. The statue was commissioned by Americans of Danish descent and dedicated in 1894.

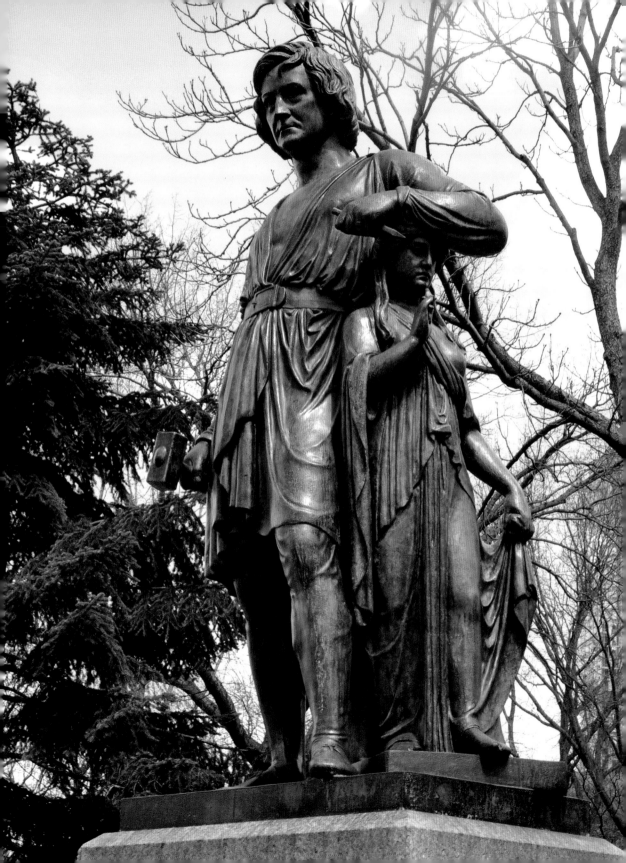

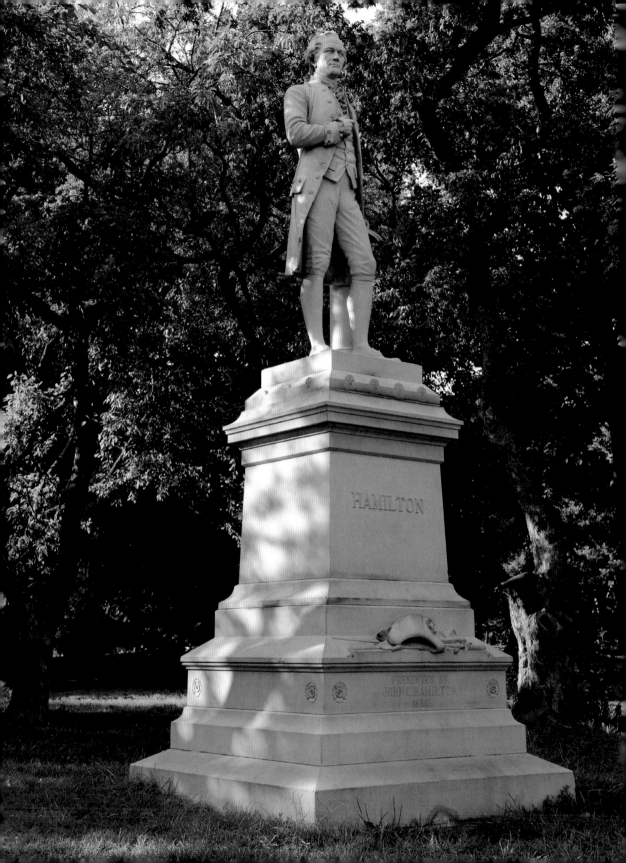

Alexander Hamilton

East Drive near East 83rd Street, Behind The Metropolitan Museum of Art

IN THE SPRING, COLORFUL BOUQUETS OF FLOWERING TREES surround this larger-than-life sculpture. Carved in stark white granite, the figure's face is familiar to many Americans as a man who played a vital role in the growth of a nation: Alexander Hamilton (1755/57–1804).

One of America's Founding Fathers, Hamilton was in fact born out of wedlock in the West Indies and orphaned before he was twelve. Members of his community recognized his keen mind and intellectual talent and sponsored his journey to America, where he attended King's College (now Columbia University). Hamilton served in the Revolutionary War and went on to become Secretary of the Treasury under the Washington administration. He went on to lead a career in law in New York City, and he also founded the Bank of New York. Hamilton died in a dramatic duel with fellow American and political rival, Aaron Burr.

Hamilton was a long-time New Yorker and traces of his life can be found all over the city. His country home, The Grange, still stands in an area of upper Manhattan known as Hamilton Heights, and he is buried in Trinity Cemetery in downtown Manhattan.

The statue of Hamilton was sculpted by American artist Carl H. Conrads and was dedicated in 1880, presented by a descendent of Hamilton, John C. Hamilton.

Alexander von Humboldt

Explorer's Gate at Central Park West and West 77th Street,
Across from The Museum of Natural History

A PEDESTAL OF WHITE WAVERLY GRANITE OVER EIGHT FEET tall elevates the oversized bust of a man wearing an attentive expression on his wrinkled face. This is Alexander von Humboldt (1769–1859), German explorer, naturalist and geographer who made many landmark scientific discoveries on his travels around the globe gathering data on plants, animals and geography. Humboldt was admired by many, including Charles Darwin, Simón Bolívar, and Thomas Jefferson.

Born in Berlin, Humboldt's pursuit of knowledge took him on distant journeys, including a Latin American expedition from 1799–1804 and a trip across the expanse of Siberia in 1829. These expeditions were tedious, difficult and often dangerous, but Humboldt uncovered as-yet unknown plants, animals and geographic landmarks. Today, species and geographical features discovered by Humboldt that bear his name include the *Lilium humboldtii,* or Humboldt's lily, found in California; the Humboldt Penguin (*Spheniscus humboldti*), a South American penguin; the Humboldt Glacier in Greenland; and the Humboldt Sink, a dry lake bed in Nevada. Humboldt dedicated his later years to writing an influential five-volume work titled *Kosmos* (1845), a comprehensive book about geography and the natural sciences.

German artist Gustaf Blaeser, an acquaintance of Humboldt, used his death mask to help sculpt a true-to-life bust of the scientist. On the other side of the Park, a painting by Julius Schrader brings Humboldt to life in full color at The Metropolitan Museum of Art.

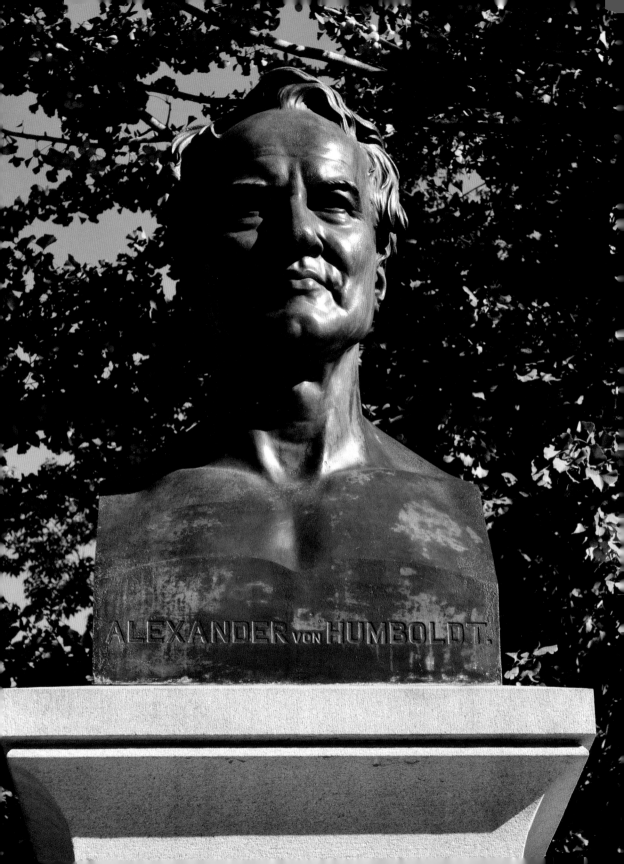

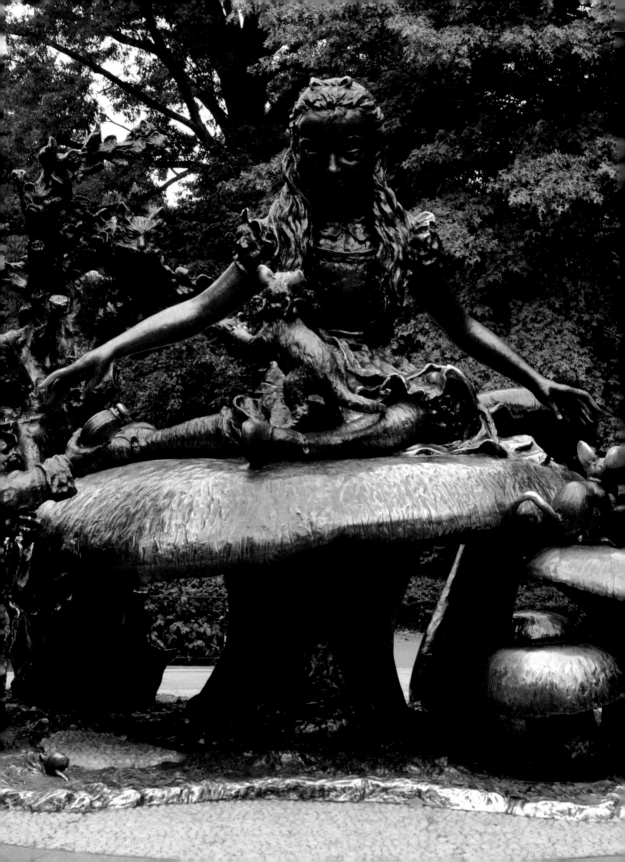

Alice in Wonderland

Conservatory Lake, Near East 75th Street and Fifth Avenue

UNLIKE MANY SCULPTURES IN CENTRAL PARK, WHICH TOWER over onlookers from perches atop high stone pedestals, *Alice in Wonderland* features a cast of characters frolicking at ground level while Alice herself welcomes visitors with open arms.

Based on Lewis Carroll's classic children's tale, the sculpture was commissioned by philanthropist George Delacorte in 1959 for the children of New York City and as a tribute to his late wife, Margarita (who often read the Lewis Carroll classic to their children).

Sculptor José de Creeft, born in Spain and trained in Paris, had the vision to create sculptures small enough for children to play on. The magical cast of characters—including the March Hare, the Mad Hatter, the Dormouse, and the Cheshire Cat—were inspired by John Tenniel's whimsical Victorian illustrations from the book's original first edition. The artist also incorporated a caricature of George Delacorte, who donated the sculpture, into his portrayal of the Mad Hatter. It is said that Alice is modeled after the artist's daughter.

The bronze sculpture was cast by the Modern Art Foundry in Long Island City, Queens. Carroll's words, carved in granite, encircle the statue, including lines from Margarita's favorite poem, "The Jabberwocky."

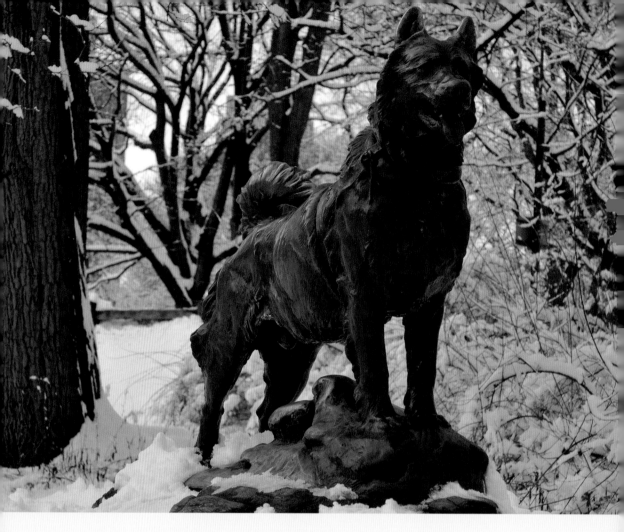

Balto

East Drive at East 67th Street

THE BRONZE SCULPTURE OF A SLED DOG PERCHED ON AN outcropping of rocks is less than three feet high, yet it tells what might be the most dramatic true story in all of Central Park.

In 1925, an outbreak of diphtheria struck Nome, Alaska in the midst of a brutally cold Alaskan winter. Supplies of medicine to halt the disease were hundreds of miles away, and with trains and planes deemed unfit for travel

in the extreme cold, a team led by sled dogs was the doctors' only hope for obtaining the life-saving medication to save the town.

Traveling with a package of medicine wrapped in fur, the team blazed a trail to Nome through a blizzard and temperatures of 50 degrees below zero. The path before them nearly invisible in the blinding white snow, sled leaders had to trust their dogs to find the way, with head sled dog Balto leading the charge. Over five days, with the whole world listening in on the expedition's progress over the radio, Balto and his team finally made it across the icy terrain to deliver the life-saving medicine.

Not long after completing the trip, Balto, a black and white Alaskan malamute, was immortalized in bronze by Brooklyn-born artist and animal sculptor Frederick George Richard Roth. Roth also created figures for *Alice in Wonderland* on the Sophie Loeb Fountain and the *Dancing Goat* and *Honey Bear* sculptures in the Central Park Zoo. Dedicated in 1925, Balto himself attended the dedication ceremony.

A plaque under the sculpture reads:

"Dedicated to the indomitable spirit of
the sled dogs
that relayed antitoxins six hundred miles over rough ice,
across treacherous waters, through Arctic blizzards from
Nenana to the relief of stricken Nome in the
Winter of 1925.
ENDURANCE • FIDELITY • INTELLIGENCE"

Bethesda Fountain

Mid-Park at Bethesda Terrace, North Side of 72nd Street

Not far from the Literary Walk, Bethesda Terrace, with its tall fountain at the center, is one of the most beautiful places to visit in all of Central Park and looks much as it did when it was first built in the 19th century. With the serene waters of Central Park Lake in the distance and the sprawling green of the Park on either side, the Terrace is an elegant centerpiece to an enchanting landscape.

Rising from the fountain at the center of the Terrace is the Angel of the Waters statue, commonly called "Bethesda Fountain." At 26 feet high, it is one of the largest fountains in New York City. It is also the only sculpture that was commissioned when the Park was originally designed. The statue, cast in bronze, is a reference to an angel in the Gospel of John who blessed the Pool of Bethesda, granting it healing powers. A lily in the angel's left hand symbolizes the water's purity.

This fountain has special meaning in the story of the city. Before the clean water system, disease spread rapidly and threatened the lives of urban residents. The opening of the Croton water system in 1842 brought fresh water from Westchester County; it is this milestone that the fountain commemorates.

The artist who created the angel statue is Emma Stebbins, the first woman granted a major public art commission in the city. Stebbins worked on creating the statue in Rome from 1861 until 1868. It was cast in 1873 in Munich and dedicated on May 31, 1873.

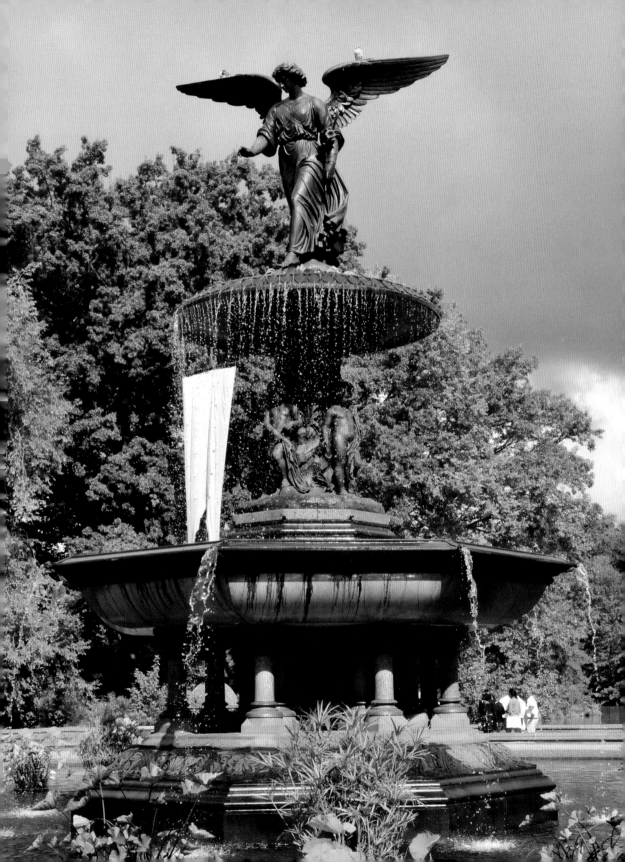

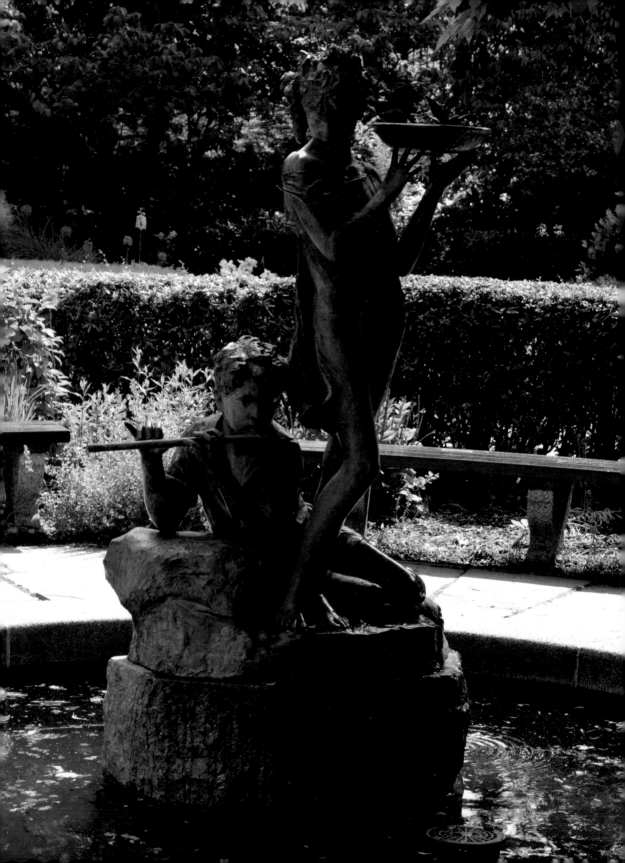

Burnett Memorial Fountain

South End of Conservatory Garden, East 104th Street

THE FIGURE OF A YOUNG GIRL WEARING A SUMMER DRESS, her hair loosely piled on top of her head, holds a bowl for a bronze bird as a boy plays the flute at her feet. During the warmer months, the bronze birds are joined by real birds stopping to enjoy the working birdbath. This sculpture, located in a fountain pool, is one of the most serene statues in the Park. It honors children's book author Frances Eliza Hodgson Burnett, author of *That Lass o' Lowrie's* (1877), *Little Lord Fauntleroy* (1886), and her most well-known work, *The Secret Garden* (1910).

The statues, created in 1926, are the work of artist Bessie Potter Vonnoh. Born in St. Louis, Missouri, Vonnoh studied at the Art Institute of Chicago and contributed work to the Horticultural Building at the Chicago's World's Fair in 1893. A prolific artist, Vonnoh rejected the formality of classicism and strove to encapsulate the energy and joy of everyday life in her art.

Conservatory Garden, where the Burnett memorial is located, features formal gardens and lawns, and is unlike any other area of the Park. One of the most charming places in the city, it is the perfect setting for a sculpture honoring Burnett's rich imagination.

Christopher Columbus

South End of The Mall, North of 65th Street Transverse

A STATUE OF CHRISTOPHER COLUMBUS CAN BE FOUND ON nearly every continent around the globe and in cities across the United States, from New York to Chicago to San Francisco. Many sculptures depict the Italian voyager standing tall and confident, a hand pointing to distant lands. The statue in Central Park, created by artist Jeronimo Sunol, however, depicts Columbus gazing heavenward, his face soft and his left hand outstretched as he gazes at the sky above him. In his right hand, Columbus holds a Spanish flag embellished with a cross.

The statue was dedicated in 1892, on the occasion of the 400th anniversary of Columbus' arrival in the Americas. Architect Napoleon le Brun designed the elegant and elaborately carved beveled pedestal that elevates Columbus.

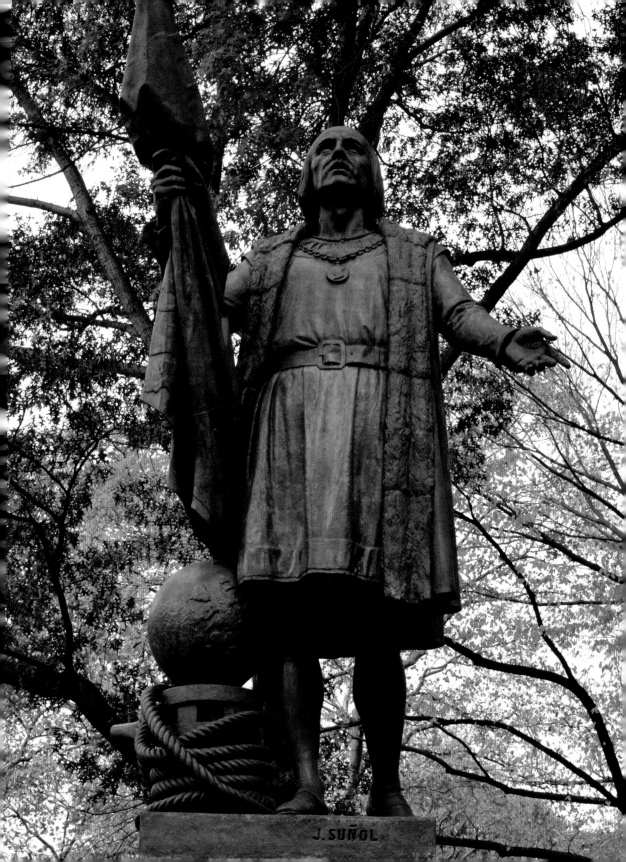

J. SUÑOL

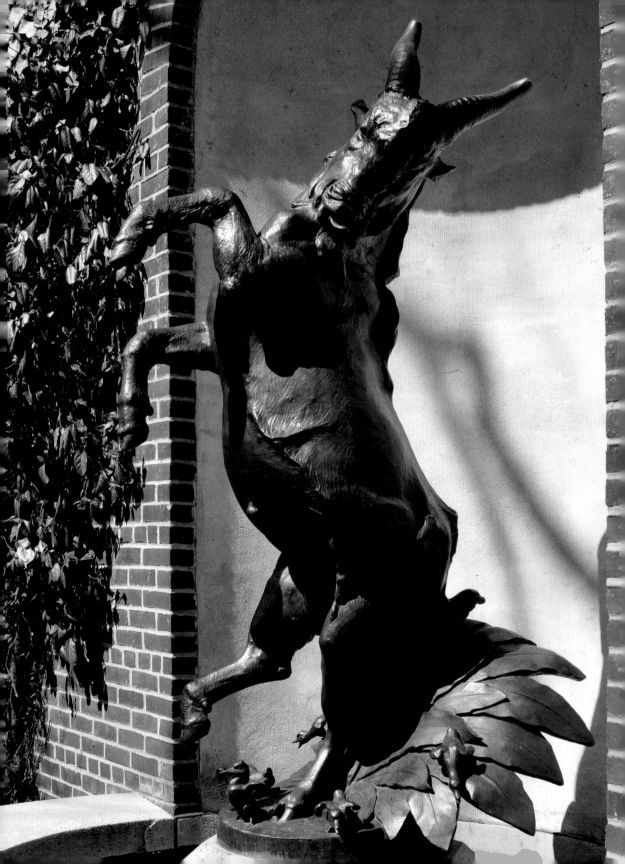

Dancing Goat 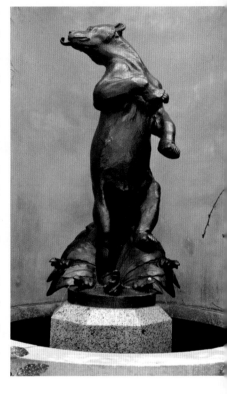 Honey Bear

Inside the Central Park Zoo, East 64th Street and Fifth Avenue

THE PLAYFUL FIGURES OF A DANCING goat and honey bear form a pair of sculptures set in fountains that welcome visitors to the Central Park Zoo. Both animals stand on their hind legs, kept company by small frogs and ducks.

Accomplished animal sculptor Frederick George Richard Roth created both pieces (Roth also created the statue of Balto the sled dog, and the Sophie Loeb fountain). After receiving numerous awards and memberships for his work, Roth was hired through the WPA (Works Progress Administration) as head sculptor for the city's Parks.

Although they look as if they could have stepped out of the forest or a busy barnyard, both *Honey Bear* and *Dancing Goat* were cast at the Roman Bronze Works in Brooklyn. The sweet bear shares a special message, the inscription reading:

HONEY BEAR
ENDOWED IN HONOR OF
SHERRY ARMSTRONG
MY LOVELY WIFE AND BEST FRIEND
LOVE, TOM
OCTOBER 30, 2007
FREDERICK G. R. ROTH, SCULPTOR
WORKS PROGRESS ADMINISTRATION PROJECT

Daniel Webster

West Drive at East 72nd Street

Not far from Strawberry Fields, near the west side of the park, the sculpture of Daniel Webster stands atop a majestic block of white Quincy granite. A larger-than-life statue, this figure of Webster originally took the form of a small statuette.

Daniel Webster served the United States for most of his lifetime in a variety of political roles, from U.S. Congressman to Senator and member of the House of Representatives, among others. Webster used his talents as a skilled orator to help keep the country united during the difficult mid-1800s, as the young nation struggled in the face of tremendous internal conflict.

Webster's sculptor, Thomas Bell, was an accomplished artist well known by many; in fact, it was thanks to Webster that Bell became one of the most famous artists in the country. Shortly before Webster died, Bell sculpted a bust of Webster, remarkable for its life-like depiction. The bust was so popular that Bell created a small statuette of the figure, going on to patent and reproduce the figure on a mass scale, making it one of the first mass-produced creations in the United States. In the 1870s, manufacturing giant Gordon W. Burnham commissioned the famous artist to create a larger-than-life version of that statuette as a sculpture for Central Park. Beneath the sculpture are inscribed Webster's famous words:

LIBERTY AND UNION,
NOW AND FOREVER,
ONE AND INSEPARABLE.

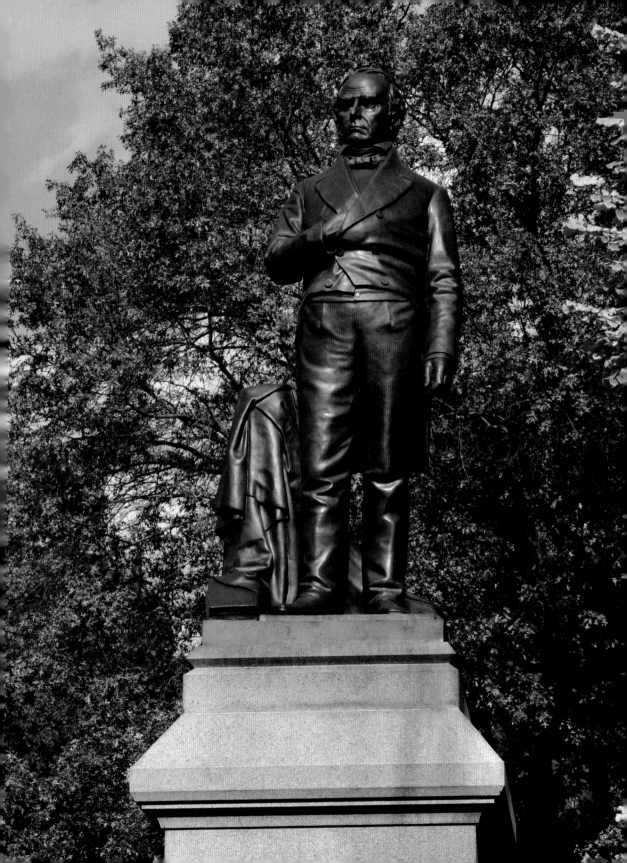

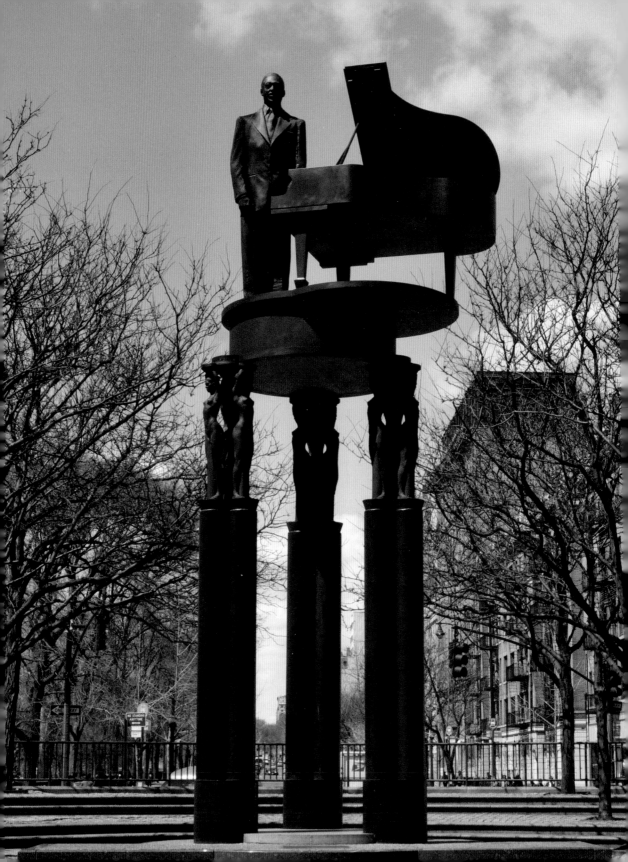

Duke Ellington Memorial

Duke Ellington Circle, Central Park North and Fifth Avenue

At the northeastern most corner of Central Park, where the green of the Park meets the grid of city streets, stands the first monument in New York City dedicated to an African-American artist and the first in the United States to honor this legendary composer, orchestra conductor, and musician: Duke Ellington (1899–1974).

Born in Washington, D.C., Ellington's refined manners earned him the name "Duke" before he was ten years old. He wrote his first composition before he could read and write music and spent many years honing his skills before moving to New York City. There, he broke into the New York jazz scene during the Harlem Renaissance of the early 1920s. Ellington and his orchestra performed at the Hollywood Club at W. 49th Street and Broadway, and later at Harlem's famed Cotton Club from 1927 to 1931. Ellington hosted radio broadcasts and recorded classics such as *Take the A Train, Sophisticated Lady*, and *Don't Get Around Much Anymore*. Ellington passed away at the age of 75 in New York City; over 12,000 people, including Ella Fitzgerald and Count Basie, attended his funeral at the Cathedral of St. John the Divine.

The artist Robert Graham created a 25 foot tall memorial of Ellington, featuring an 8 foot tall Duke standing beside an open grand piano and three columns decorated with figures of the muses. Beneath the monument is an amphitheatre for performance and seating. The sculpture was unveiled at the gateway to Central Park and Harlem in July of 1997 to a crowd of admirers and the sound of music written by the Duke himself.

Eagles and Prey

West of The Mall

ONE OF THE MOST DYNAMIC SCULPTURES IN THE PARK, *Eagles and Prey* masterfully captures the power of the animal kingdom, the curves of the eagles' swooping wings beautifully mirroring the arches of the tree branches in the distance.

Commissioned by the same businessman who brought the statue of Daniel Webster to the Park, Gordon Webster Burnham, *Eagles and Prey* was created by French artist Christophe Fratin. Fratin trained in the atelier of famous French painter Gericault and was well known throughout Europe for his animal sculptures. *Eagles and Prey* depicts a dramatic moment from the natural world, as a goat is captured by eagles and lies helpless in their powerful talons.

The oldest sculpture in the park, *Eagles and Prey* was installed in 1863. Initially, the sculpture's stark portrayal of wildlife was met with criticism, and seen as a disruption to the Park's tranquility. But over time, the sculpture came to be admired for its heart-stopping realism. The astonishing sculpture features remarkable detail, the eagles' feathers so precisely rendered that the birds almost seem as if they could fly away.

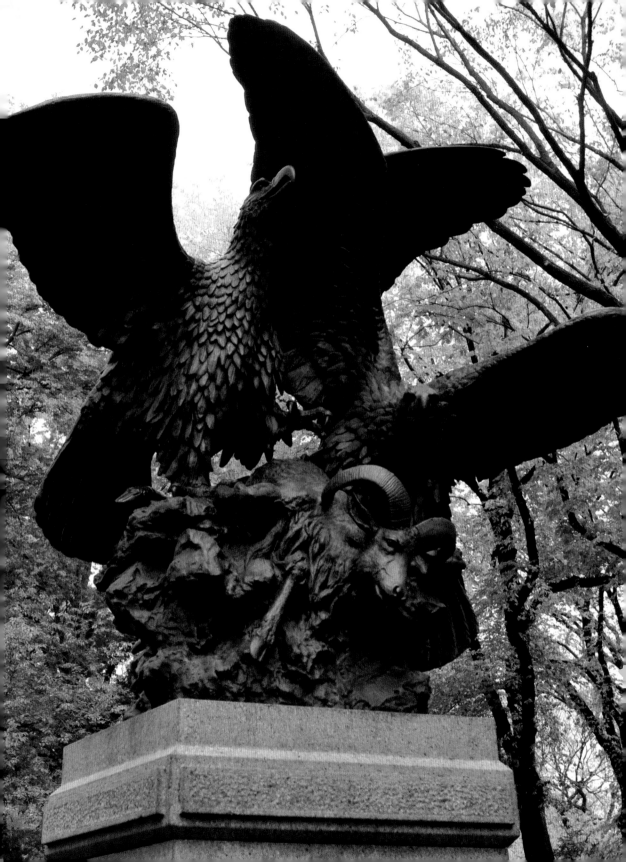

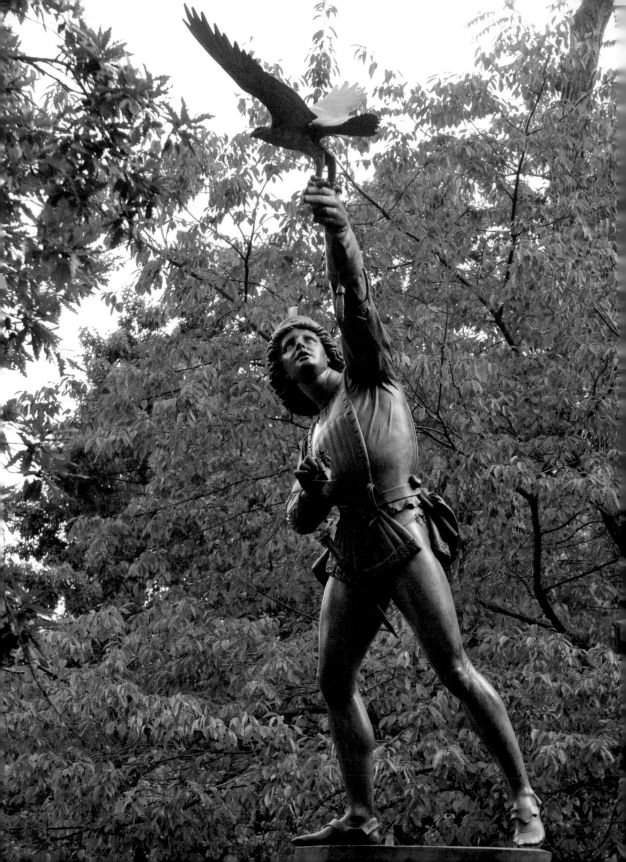

The Falconer

South of West 72nd Street Transverse

THE FALCONER IS PERHAPS ONE OF THE MOST ELEGANT figures in Central Park. Clad in Elizabethan dress, the falconer lifts his left arm skyward towards a falcon, its wide wings outstretched. A simple granite pedestal elevates the figures over four feet into the air above the rock outcropping on which the sculpture rests. A tribute to man's admiration for the graceful birds of prey, the sculpture also pays homage to the many bird species that call the Park their home, including peregrine falcons and red-tailed hawks.

The statue was created by British sculptor George Blackall Simonds in 1871 and dedicated in 1875. Simonds was a falconer himself and impressed many with his statue.

Fitz-Greene Halleck

The Mall

POET AND ESSAYIST FITZ-GREENE HALLECK IS MOST well-known by virtue of *not* being well known; he is the least recognized literary figure on the Mall's Literary Walk. Interestingly enough, he has close ties to the more popular Robert Burns, who stands not far from Halleck: Halleck wrote lyrics for the Scottish poet.

Hailing from Connecticut and distantly related to the Pilgrims, Halleck was once a personal secretary to John Jacob Astor. His most popular work during his lifetime was a poem called *Marco Bozzaris*, which was often recited in classrooms as a learning tool.

Sculptor James MacDonald depicts Halleck seated, with a pen in one hand and a book in the other. The sculpture was commissioned in 1867 and dedicated in 1877 by U.S. President Rutherford B. Hayes to a crowd of nearly 10,000 people.

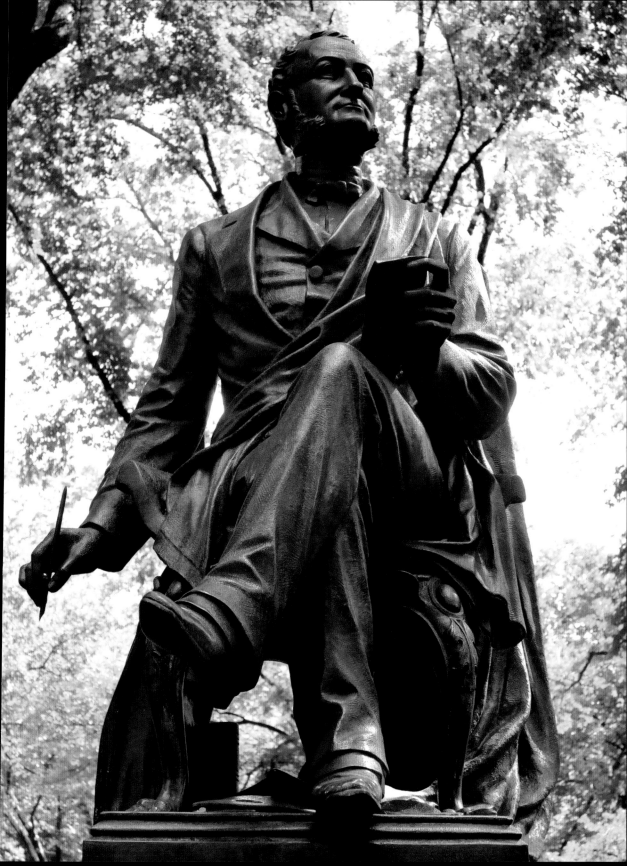

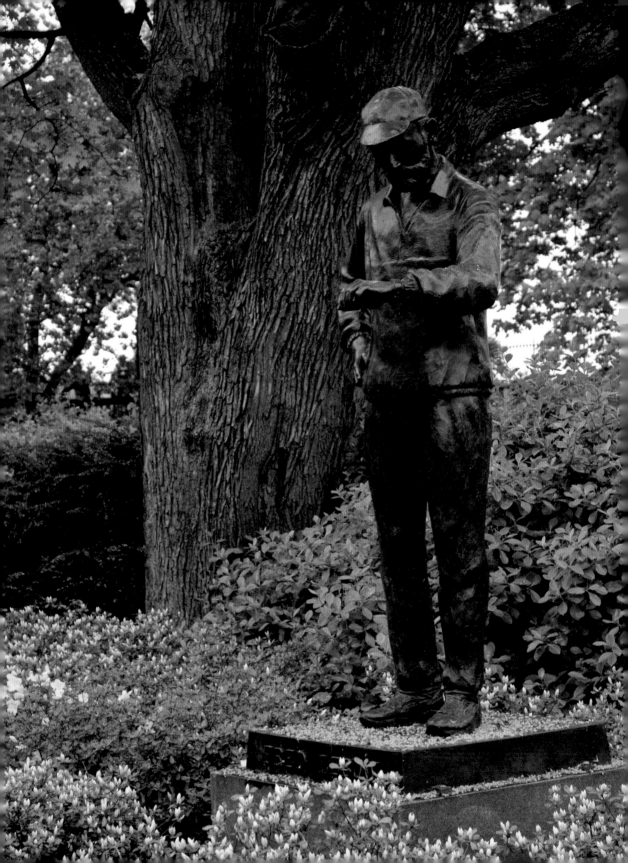

Fred Lebow

East Drive at East 90th Street

THE SCULPTURE OF A MAN WEARING A BASEBALL CAP, DRESSED in a running suit and staring at his watch, is Fred Lebow (1932–1994), founder of the world-famous New York City Marathon and longtime president of the New York Road Runners Club.

Lebow was born in Romania and, after surviving the Nazi occupation in World War II, settled in New York City in the 1960s where he had a successful career in the garment business. But it was running, which he discovered later in life, that was his true passion. Determined to share the joy of the sport with as many people as possible, he expanded the New York City marathon from a race with 127 runners that never left Central Park to an internationally-renowned event with over 50,000 participants with a route that passes through all five boroughs. When Lebow passed away in 1994 from cancer at the age of 62, his memorial tribute in the Park was attended by over 3,000 mourners—one of the largest gatherings in the Park's history.

The life-sized bronze sculpture by artist Jesus Ygnacio Dominguez, unveiled in 1994, has the unique distinction of being moved every year. During the Marathon each November, Lebow is placed by the end of the race near 67th Street, where marathoners can imagine him rooting for them as they cross the finish line to the cheers of the crowd.

Frederick Douglass

Central Park North and Frederick Douglass Boulevard

AN ENGAGING, EXPERIENTIAL MONUMENT, THE FREDERICK Douglass circle honors the famed abolitionist, women's suffragist, writer, editor, orator, and publisher who changed the fabric of American history.

Born Frederick Augustus Washington Bailey in Talbot County, Maryland in 1818, Douglass was born into slavery. He escaped at the age of 20 and fled to New York, where he took the name Frederick Douglass and became known as a leader in the abolitionist movement with impressive oratory skill. He published the abolitionist journal *The North Star,* which also supported the women's suffrage movement; the journal's title referred to the constellation slaves used to guide them on their journey on the Underground Railroad. After the Civil War, Douglass worked in several roles for the government, including Assistant Secretary of the Santo Domingo Commission and Marshall of the District of Columbia, before passing away in Washington, D.C. on February 20, 1895.

The memorial to Frederick Douglass was dedicated in September of 2011. Hungarian-born sculptor Gabriel Koren created the bronze sculpture of Douglas, and local Harlem artist Algrenon Miller designed an all-encompassing tribute to Douglass in the memorial site. Miller included a pattern in the pavement that echoes the designs of African-American quilts, a fence with the patterns of a wagon wheel, a water wall, and carved quotations from Douglass himself to tell the story of his life and the journey from slavery to freedom.

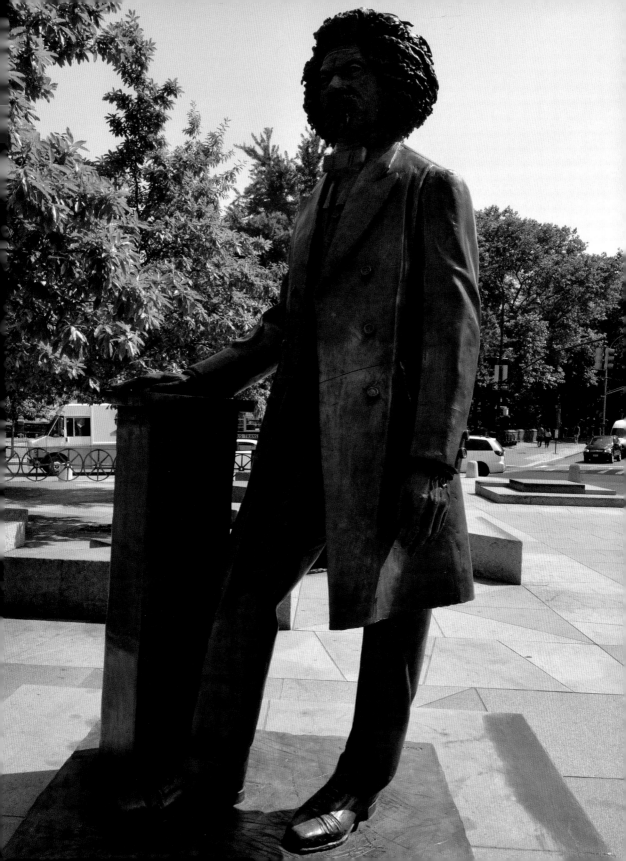

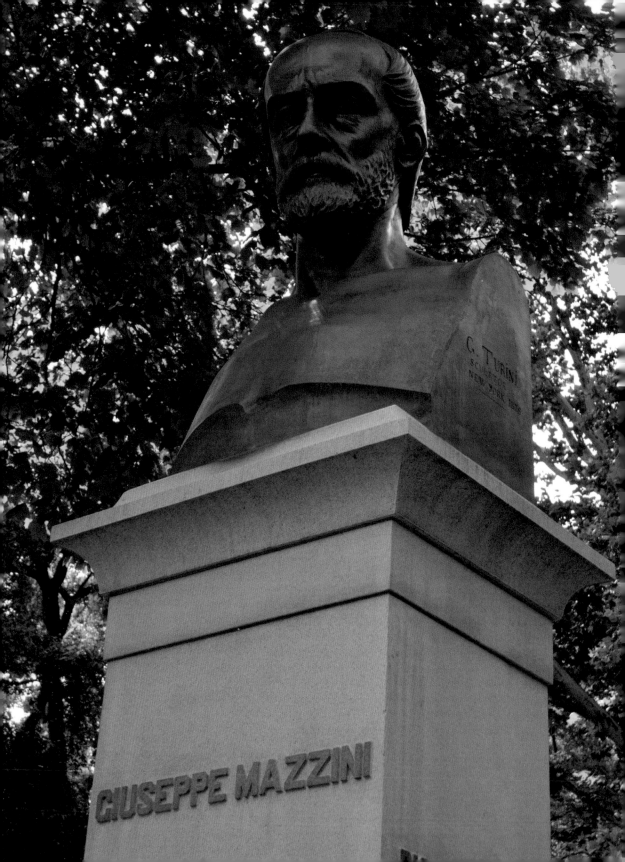

GIUSEPPE MAZZINI

Giuseppe Mazzini

West Drive, Near West 68th Street

IN THE SPRING, LONG ARMS OF FLOWERING TREE BRANCHES dotted with pink appear behind the bust of Giuseppe Mazzini, complementing the leathery color of the sculpture's aged bronze. The face of Mazzini is depicted with great realism and, despite being elevated on a pedestal of white Westerly granite, the bust seems almost humble: Mazzini's shoulders and chest are bare, and there are wrinkles on his forehead and bags under his eyes. Yet this bust honors a legendary man who fought to unite a nation.

An Italian patriot, philosopher and politician, Mazzini worked to unify Italy during the mid 1800s, organizing protests and driving political opinion even after he was forced into exile. Upon Mazzini's death, it is said that over 80,000 people attended his funeral in Genoa in 1872.

Italian-born sculptor Giovanni Turini created the bust of Mazzini, which was donated by Italians in the United States of America. The sculpture was dedicated in 1878. The bust's granite pedestal is inscribed with phrases that read, in Italian: "thought and action," and "God and the people."

Hans Christian Andersen

Conservatory Lake, Near East Drive and East 74th Street

SINCE 1955, THE LARGER-THAN-LIFE FIGURE OF HANS Christian Andersen, seated on a bench of Stony Creek pink granite, has welcomed passersby to sit beside him. Andersen, Danish poet, novelist, and author of many children's classics including *The Ugly Duckling* and *The Little Mermaid*, is depicted reading pages from *The Ugly Duckling* to a small bronze duckling at his feet.

Georg John Lober sculpted the bronze figure of Andersen, carefully recreating life-like details of the author's large tie and three-piece suit, and making the sculpture oversized so that children can sit on Andersen's knee and peer at the text in the large book that begins:

"It was beautiful in the country. It was summer.
The wheat fields were golden..."

The statue was presented in 1955 in honor of the 150th anniversary of Andersen's birthday. Countless children have sat on Andersen's lap over the years, and since 1966, a reading program for children has brought the magic of storytelling to the Park, a truly fitting way to honor the beloved author.

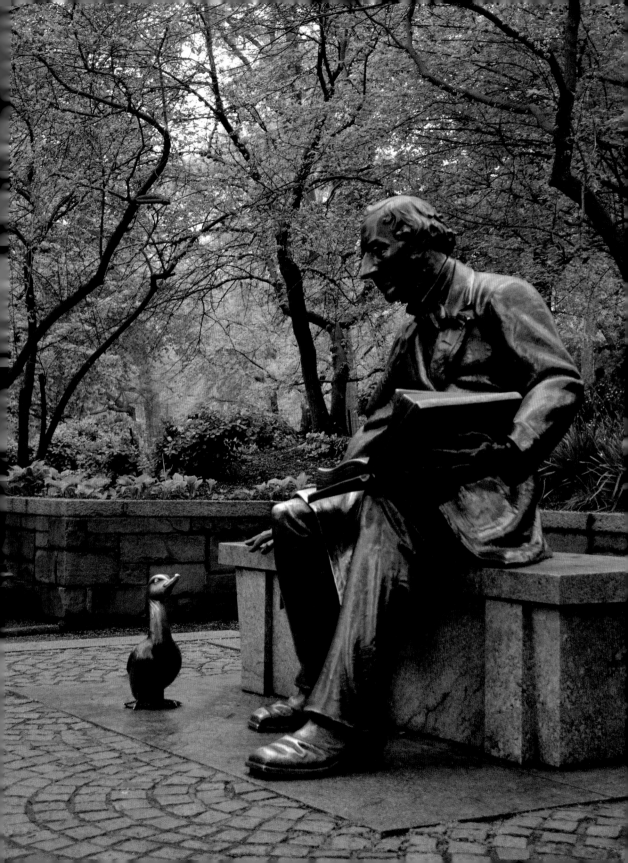

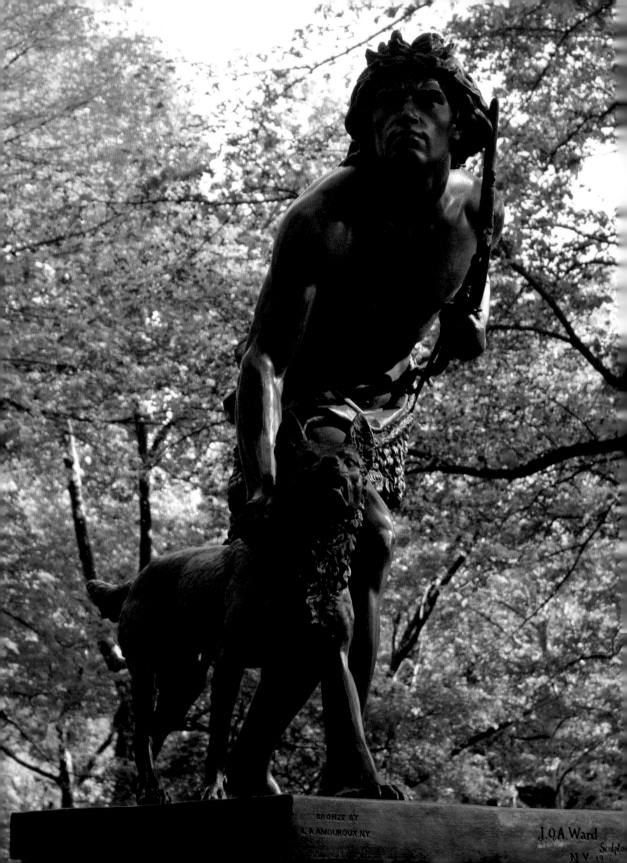

BRONZE BY
L. A. AMOUROUX. N.Y.

J.Q.A. Ward
Sculptor
N.Y. 1866

Indian Hunter

West of The Mall

THE INDIAN HUNTER IS ONE OF THE MOST REALISTIC and arresting sculptures in Central Park. Depicting a young hunter, bow at the ready and eyes alert with his dog beside him, the hunter leans forward as he advances in careful silence, stalking his prey.

The sculpture, crafted by artist John Quincy Adams Ward, was the first sculpture by an American artist to be placed in the Park. Ward was dubbed "the dean of American sculptors" for his skills at portraying realism and tension in moments taken from life. Cast in 1866 and dedicated in 1869, *Indian Hunter* was praised for "its bold and vigorous treatment, and its truthful delineation."

Indian Hunter is just one of the many sculptures that Ward created for New York City; other works include *Roscoe Conkling* (1893), in Madison Square Park; *Alexander Holley* (1888), in Washington Square Park; *William Earl Dodge* (1885), now in Bryant Park; as well as other sculptures in Central Park, including *William Shakespeare* (1872), *The Pilgrim* (1885), and the *Seventh Regiment Memorial* (1874) (see right).

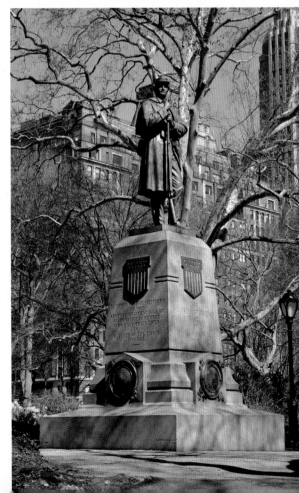

King Jagiello

East End of Turtle Pond, Across from Belvedere Castle

IT IS VIRTUALLY IMPOSSIBLE TO WALK PAST THE EAST side of Turtle Pond without noticing the figure of a king on a horse holding two swords over his head, his gaze fierce and intent beneath his large crown. Elevated on a massive granite plinth, this bronze sculpture depicts King Wladyslw II Jagiello of Poland during the historic Battle of Grunwald in 1410.

King Jagiello, the Grand Duke of Lithuania, married the Queen of Poland in 1386, uniting Lithuania and Poland. The monument immortalizes the king's triumph over the Teutonic Knights of the Cross during the Battle of Grunwald, the crossed swords raised above his head in a gesture symbolizing the union of Poland and Lithuania.

Artist Stanislaw K. Ostrowski created the monument to lend to the United States for the Polish pavilion at the 1939 New York World's Fair in Flushing Meadows, Queens. The sculpture was to be returned to Poland, but later that year the Nazis invaded Poland, preventing the statue's return. In 1945, the Polish government placed the sculpture in Central Park in honor of the spirit of the Polish people.

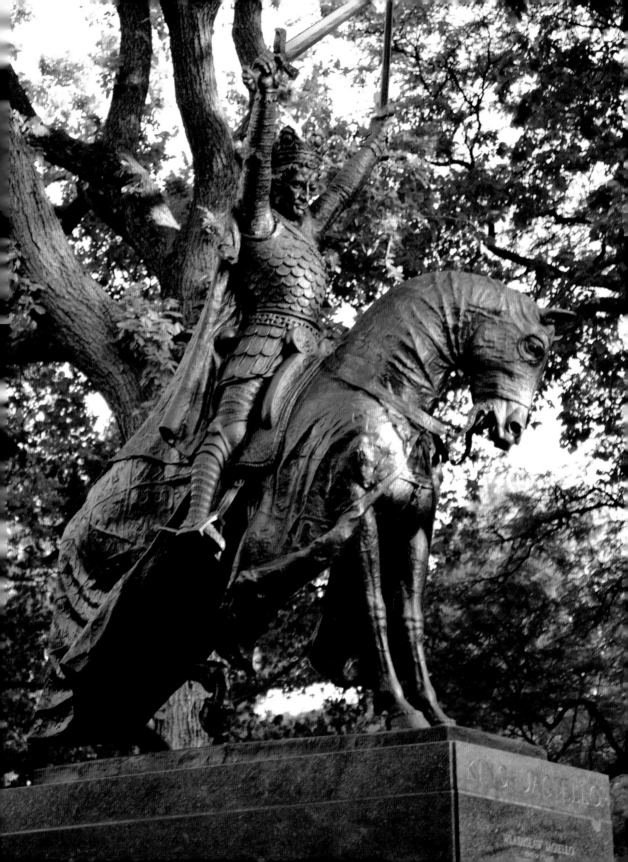

Johann Christoph Friedrich von Schiller

The Mall

BORN IN 1759, VON SCHILLER WAS A GERMAN POET, playwright and philosopher considered by many to be Germany's most valuable classical playwright. During the last 17 years of his life, Schiller became close friends with influential writer and politician, Johann Wolfgang von Goethe. Together, the two men founded the Court Theatre in Weimar, Germany, which led to a rebirth of German drama. Beethoven himself said that setting the poetry of Schiller to music was impossible, because the composer must be on par with the poet, and Schiller's work was too wonderful to match.

Elevated on a pedestal of Saguenan red granite, the bronze bust has been colored over time to a dark green that nearly blends with the foliage behind it in the spring and summer months. The piece was created by German artist C. L. Richter and based on an earlier marble bust by fellow German artist Heinrich Dannecker in 1805. His brow furrowed in concentration, Schiller is depicted with an unclothed chest and long, unkempt hair, perhaps echoing the tone of the Romantic school on which he had lasting influence.

A gift of New York's German-American community, the bust was dedicated in November 1859 on the centennial of Schiller's birth.

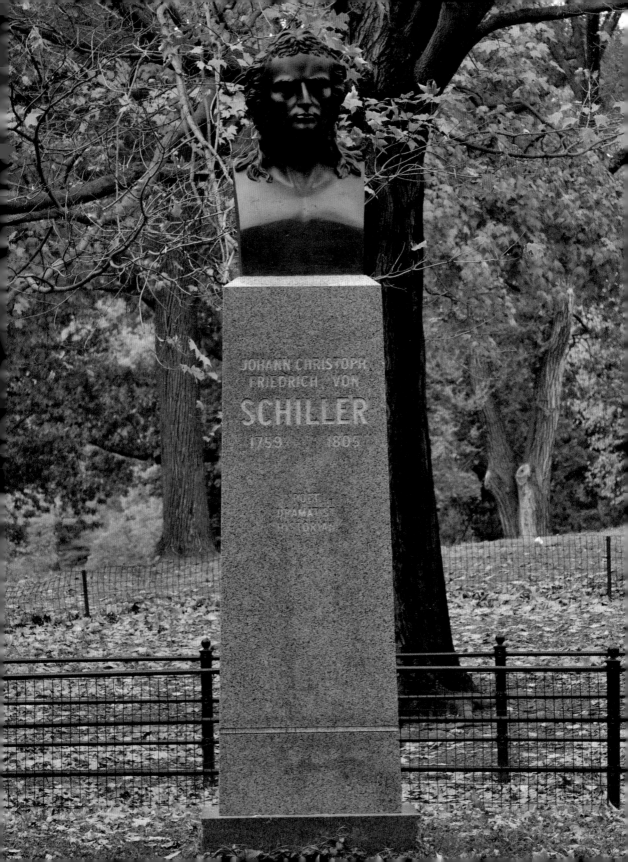

JOHANN CHRISTOPH
FRIEDRICH VON

SCHILLER

1759 1805

POET
DRAMATIST
HISTORIAN

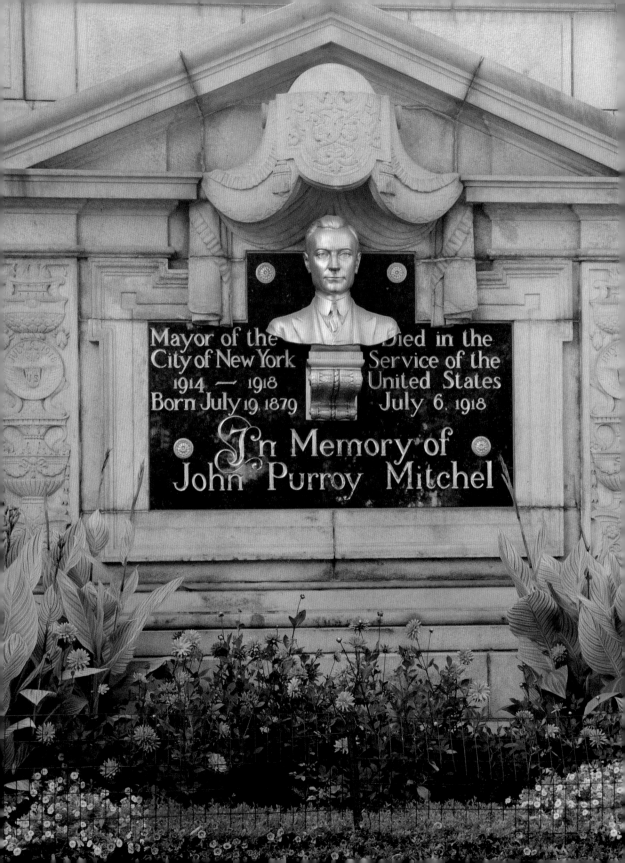

Mayor of the
City of New York
1914 — 1918
Born July 19, 1879

Died in the
Service of the
United States
July 6, 1918

In Memory of
John Purroy Mitchel

John Purroy Mitchel

Eastern Embankment of Jacqueline Kennedy Onassis Reservoir,
East 90th Street and Fifth Avenue

THE BLACK AND GOLD MONUMENT, PLACED UNDER A canopy carved of stone near Central Park's Reservoir at 90th Street, honors Mayor John Purroy Mitchel, known as the "The Boy Mayor of New York." Mitchell was New York City's youngest mayor, taking office in 1913 when he was only 34 years old. Despite his young age, Mitchel left an important mark on the history of New York City.

Born and raised in the Fordham section of the Bronx, Mitchel attended Columbia University and went on to become mayor of New York from 1914 to 1917. During his years as mayor, he was credited for ferreting out Tammany Hall corruption and was admired by many for his honesty and uncompromising ideals.

After his bid for re-election was unsuccessful, Mitchel enlisted to serve his country in the last months of WWI. He died in an airplane accident in the summer of 1918 during a training flight in Lake Charles, Louisiana, when he was only 39.

German-born sculptor Adolph Alexander Weinman created the gilded bronze portrait bust to honor Mitchel. The location near the reservoir was chosen because Mitchel presided over the opening of the first water tunnel in 1917.

José de San Martín

Central Park South and Avenue of the Americas

A BLOCK OF POLISHED BLACK GRANITE REFLECTING THE trees of the Park on one side and the busy traffic of the Avenue on the other raises an equestrian statue well over 20 feet in the air. The sculpture depicts a horse rearing up on its hind legs, as its rider, unafraid, points off in the distance. This memorial honors Argentine general José de San Martín (1778–1850) who helped liberate Argentina, Chile and Peru from Spain in the early 19th century.

The sculpture was given to the city of New York in 1950 by Buenos Aires in exchange for a statue of General George Washington, to whom San Martín is often compared. A statue of San Martín residing in Washington, D.C. bears the inscription:

> *HIS NAME LIKE WASHINGTON'S*
> *REPRESENTS THE AMERICAN IDEAL OF*
> *DEMOCRACY, JUSTICE AND LIBERTY.*

The piece is a replica of the original, larger sculpture created in 1862 by French sculptor Louis Joseph Daumas (1801–1887), which resides in the Plaza San Martín in Buenos Aires. San Martín, with the sculpture of Simón Bolívar and José Julián Martí, form a trio of sculptures honoring Latin-American leaders in Central Park.

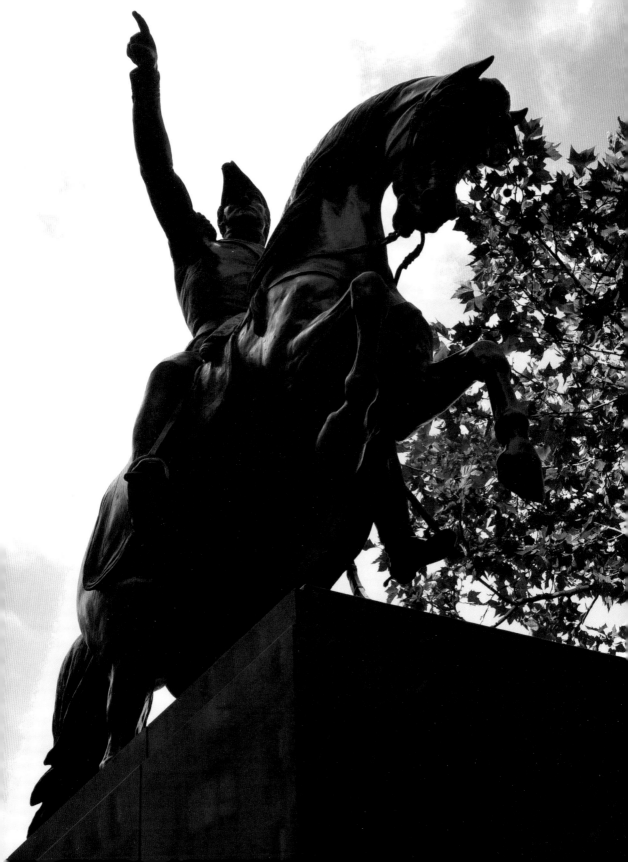

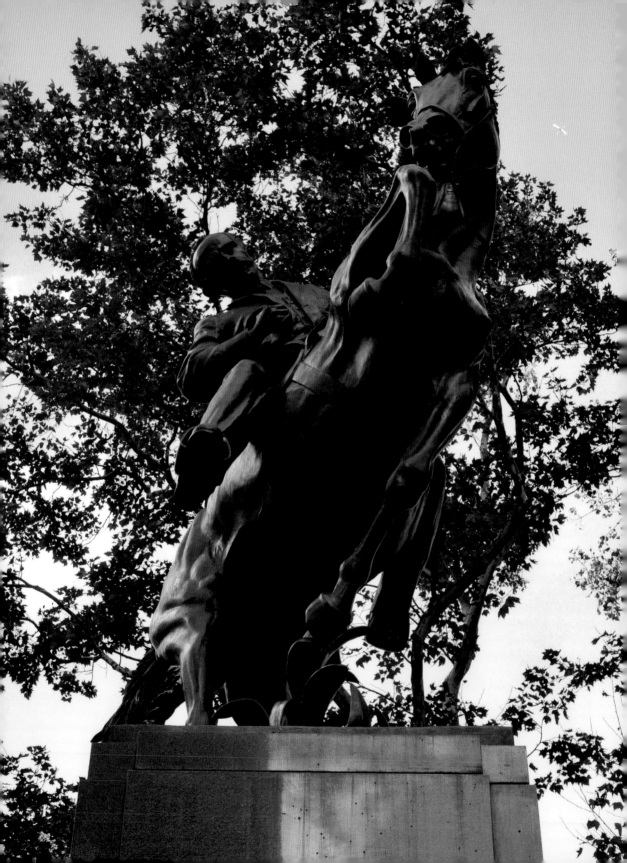

José Julián Martí

Central Park South and Avenue of the Americas

OVER SIXTEEN FEET OF GLEAMING BLACK GRANITE ELEVATES one of the most dramatic statues in Central Park. The sculpture tells a true story of a tragic moment; when the horse, panicked, rears up on its hind legs in response to the mortal injury just inflicted upon its rider, José Julián Martí.

A Latin American hero, Martí was a Cuban patriot, poet and journalist who fought to liberate Cuba from Spain. Imprisoned by the Spanish in 1868, he fled to New York in 1880 and later returned to Cuba in 1895 when Cuba renewed its fight for independence. It was during 1895, at the battle at Dos Rios, that Martí was killed.

Martí was depicted by Anna Vaughn Hyatt Huntington, who also created the sculpture of Joan of Arc astride a horse that stands in Riverside Park. Sculpted when she was 82, Martí was Hyatt Huntington's last major work of art.

Lehman Gates

Tisch Children's Zoo Entrance,
Near East 66th Street and Fifth Avenue

The playful, swirling curls of the Lehman Gates welcome visitors to the Central Park Zoo. The gates were designed by Edward Coe Embury (1906–1990) and sculpted by Paul Manship (1885–1966). Manship also created the famous golden figure of *Prometheus* at Rockefeller Center and *Group of Bears* (see next page) near The Metropolitan Museum of Art.

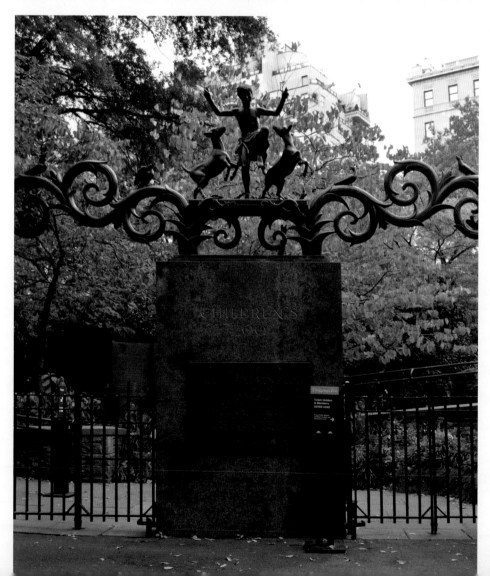

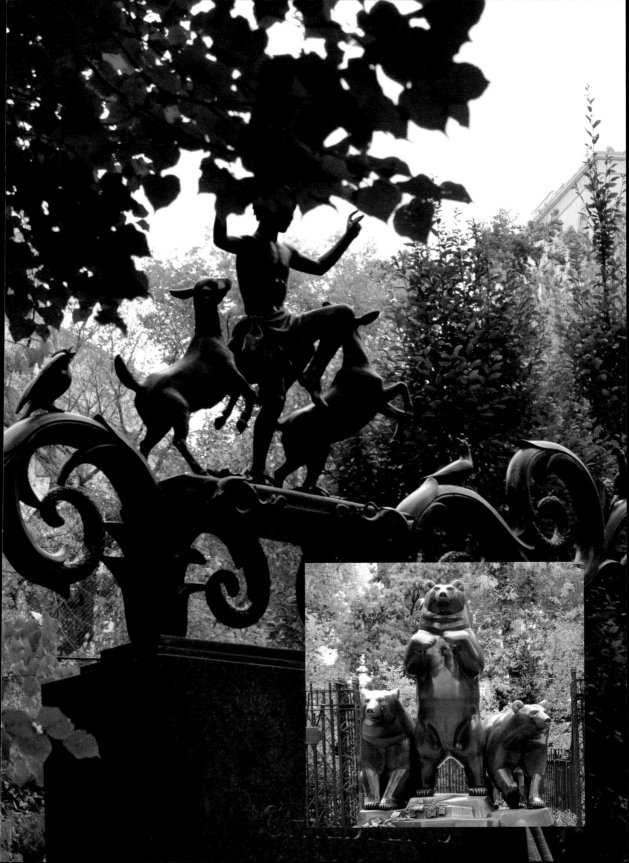

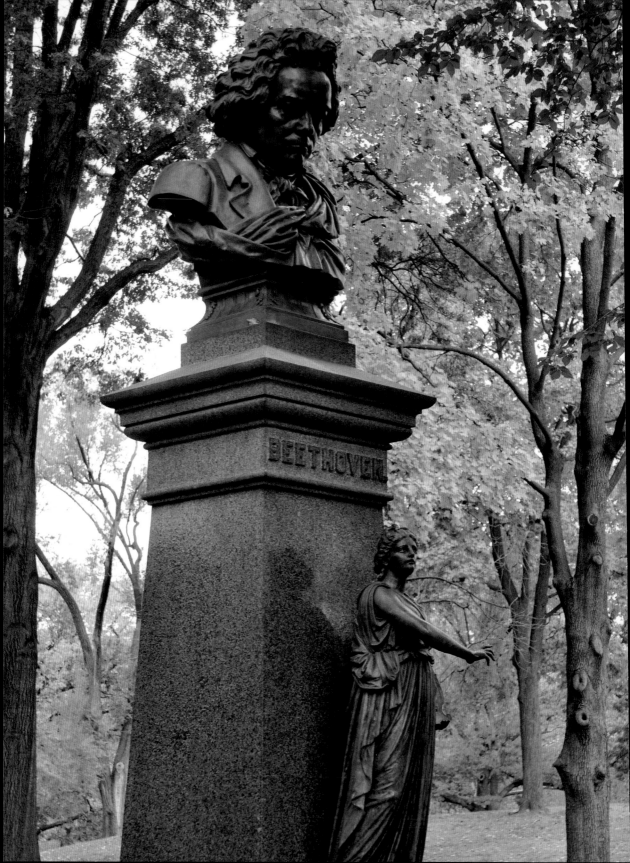

Ludwig van Beethoven

West of The Mall, Across from Naumberg Bandshell

THE BUST OF BEETHOVEN MARKS AN AREA OF THE PARK that once featured a cast-iron bandstand dedicated to outdoor concerts. In the 1800s, thousands of people would flock to the park for free performances in the open air. Today, the bandstand is long gone, but benches still sit where music lovers once gathered, while Beethoven looks out over the crowd.

Born in Germany, Beethoven studied with Mozart and Haydn. Prevented by growing deafness from performing as a pianist, Beethoven nonetheless composed amazing works of music, including the Fifth Symphony and the Ninth Symphony.

Well-known German portrait sculptor Henry Baerer was chosen to carve the bust of Beethoven for Central Park, and depicted the composer with his trademark look of intensity. A personification of "the Genius of Music" stands in front of the barre granite pedestal, elevating the bust. The German-American Choir Society, whose members frequently performed in the Park, placed the sculpture and dedicated it in 1884.

Mother Goose

East Drive at East 71st Street, Near Rumsey Playfield

Her cape flying behind her, Mother Goose seems to sail through the air on top of her magical flying goose. Humpty Dumpty, Old King Cole, Little Jack Horner and other well-known characters from *The Tales of Mother Goose* decorate the swirls beneath the goose's wings. Frederick George Richard Roth (1872–1944) brought Mother Goose to life out of a single, 13-ton piece of Westerly granite.

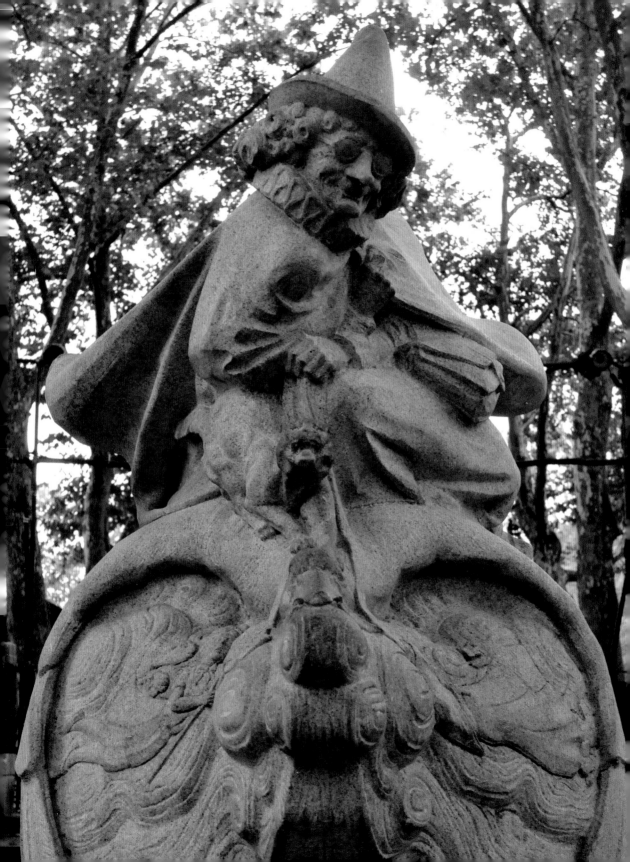

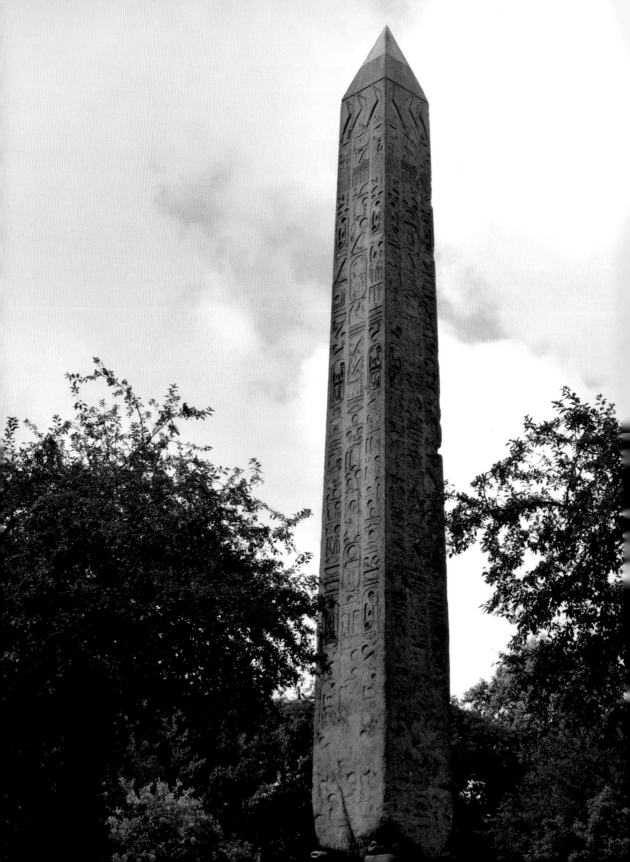

The Obelisk

East Drive at East 81st Street,
Behind The Metropolitan Museum of Art

HIGH ON A HILL OVERLOOKING CENTRAL PARK, THE OBELISK, also known as Cleopatra's Needle, links the City of New York to the banks of the Nile and tells a story that stretches back thousands of years.

In 1475 B.C., an Egyptian pharaoh erected two obelisks, created in celebration of his thirty years as ruler, in the city of Heliopolis. Centuries later, circa 12 A.D., the great monuments were transported to Alexandria by the Romans. There they remained until the nineteenth century, when one obelisk went to London, in 1878, and the other to New York City. It was only after a slow, 112-day journey from a seaport on the banks of the Hudson River to the northeast side of Manhattan that the obelisk finally arrived in Central Park, where it was raised upright in front of a crowd of thousands on January 22, 1881.

This great monument hides a secret. Beneath it is a time capsule, buried when the obelisk was erected in the Park. Items inside include an 1870 U.S. Census; a Bible; the complete works of Shakespeare; and a box placed by the man who helped bring the obelisk to New York City, its contents known only to the man who buried it.

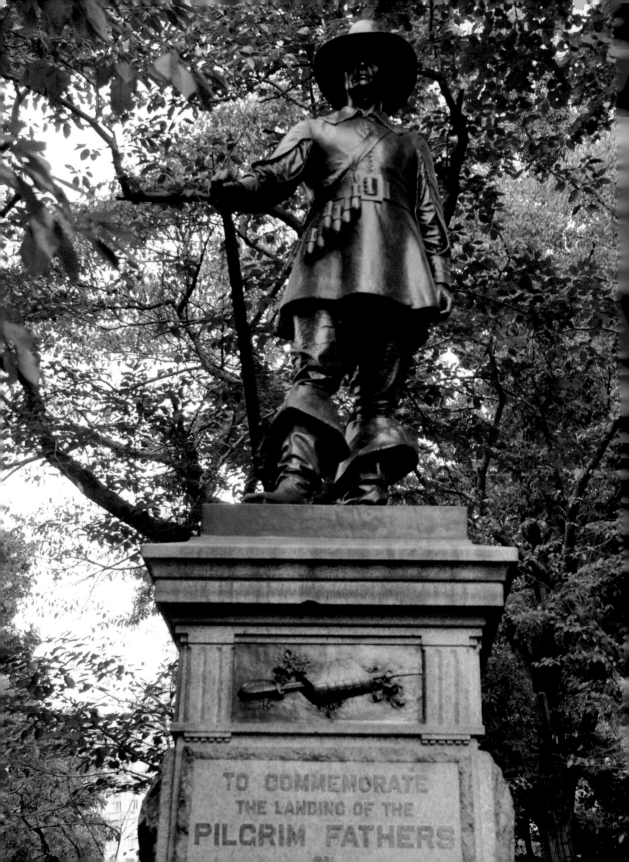

TO COMMEMORATE
THE LANDING OF THE
PILGRIM FATHERS

The Pilgrim

Pilgrim Hill, East 72nd Street and Fifth Avenue

ACCLAIMED SCULPTOR JOHN QUINCY ADAMS WARD created *The Pilgrim*, a sculpture honoring the Pilgrims who landed at Massachusetts Plymouth Rock in 1620. Ward included all the details of a pilgrim's dress in his sculpture, from the broad belt buckle to the large hat and black boots. Cast in dark bronze, *The Pilgrim* seems to look to the future with eagerness and anticipation. *The Pilgrim* is elevated above the Park on a sixteen-foot tall block of Quincy granite. The piece was given to the Park as a gift from the New England Society and presented in 1885.

The small hill upon which the sculpture stands is known as Pilgrim Hill. In the spring, clouds of pinkish white cherry blossoms decorate the hill, and in winter, after a good snowfall, Pilgrim Hill is a popular spot for sledding.

Pulitzer Fountain

Grand Army Plaza, East 59th Street and Fifth Avenue

In his will, newspaper publisher Joseph Pulitzer left funds for the construction of the Pulitzer Fountain. Created by artist Karl Bitter, the sculpture at the center of the fountain depicts Pomona, the Roman goddess of abundance. The model who posed for Pomona, Audrey Munson, is also represented in the gold figure atop the Manhattan Municipal Building downtown and in numerous sculptures and memorials throughout New York City, including the USS Maine Monument at the southwest corner of Central Park just a short walk from the Fountain.

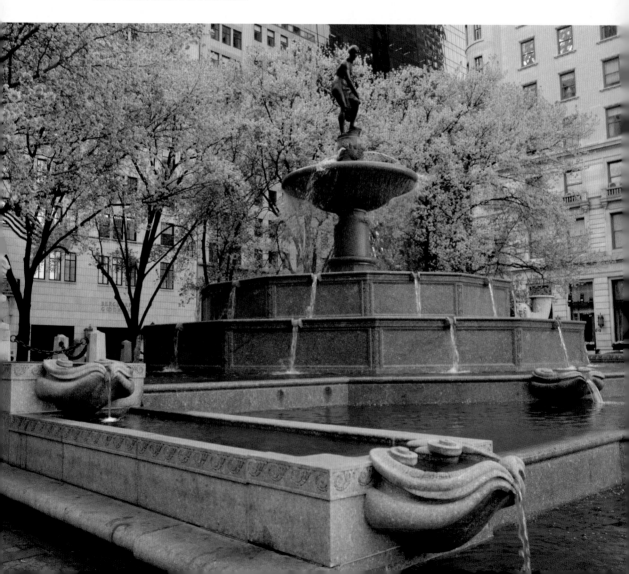

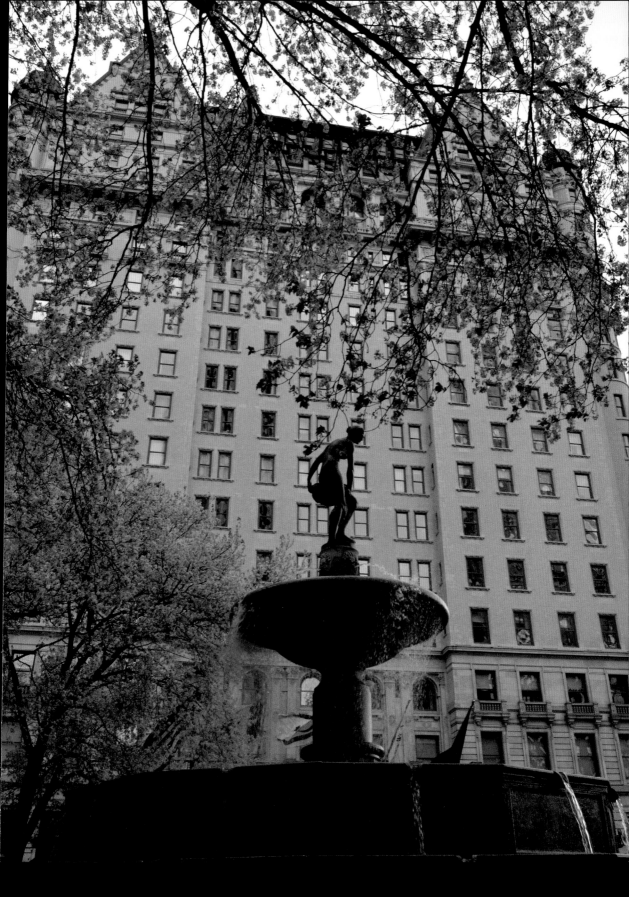

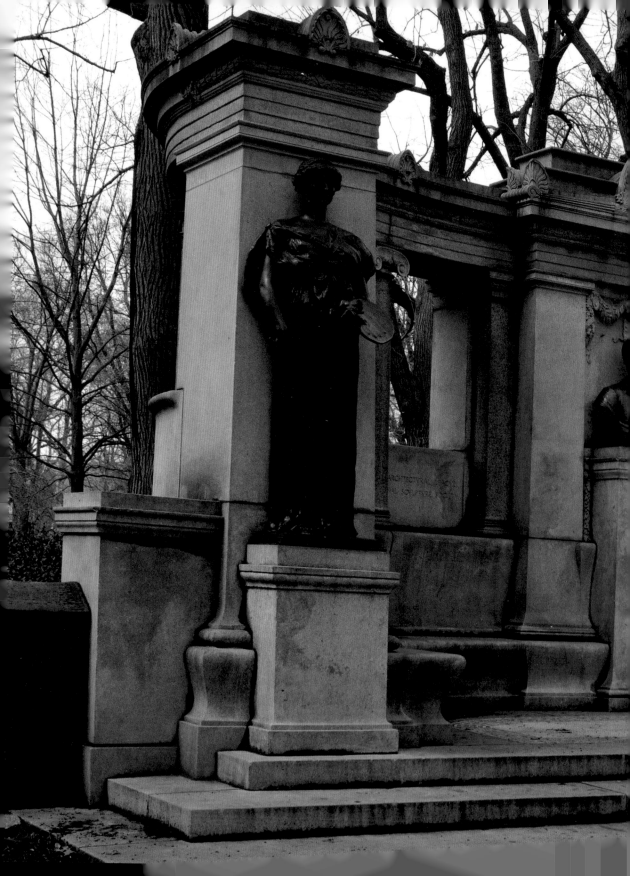

Richard Morris Hunt

East Side Perimeter Wall, East 70th Street and Fifth Avenue,
Across from The Frick Museum

THE MEMORIAL TO RICHARD MORRIS HUNT (1827–1895) is not merely a sculpture or a bust, but a space created for the viewer to experience. This is a fitting tribute to an architect who created many homes and spaces for New Yorkers, and who holds a preeminent position in the history of American architecture.

Born in Vermont, Hunt was the first American to study at the École des Beaux-Arts in Paris. He returned to New York and soon became the city's most famous architect, introducing a new style of Gilded Age grandeur in the mansions he built on Fifth Avenue. He also shaped the face of the City, constructing the columns of the Metropolitan Museum of Art, the pedestal of the Statue of Liberty, the now demolished New York Tribune Building, and the charity hospital known as the Association for the Relief of Respectable Aged Indigent Females (1883), now a youth hostel on Amsterdam Avenue at 103rd street. He also founded the American Institute of Architects and the Municipal Art Society, and demanded that architects be treated as respected professionals. Hunt's unpretentiousness and enthusiasm made a lasting impression on many, including the American poet Ralph Waldo Emerson.

In 1898, three years after Hunt's death, sculptor Daniel Chester French, who also created the monument to Abraham Lincoln in the Lincoln Memorial in Washington, D.C., was chosen to honor Hunt's memory.

Robert Burns

The Mall

A YOUNG MAN LOOKS SKYWARD, HIS MIND LOST IN THOUGHT. His body is relaxed, his ankles loosely crossed and his left hand resting on a stump by his side. Only his right hand seems electrified, poised with a quill pen between his fingers. At his feet is a scroll, inscribed with the words of a poem dedicated to his lost love, Mary. This passionate figure is Scotland's national poet Robert Burns, well-known for his song *Auld Lang Syne*, and his genius at using the rhythms and dialects of everyday speech in his poetry.

The Central Park sculpture of Burns was the first sculpture of the poet to be erected outside of Scotland and was sculpted by Victorian artist Sir John Steell (1804–1891). A Scotsman himself, Steell was an accomplished artist who had been appointed Sculptor of the Queen of Scotland in 1838. Steell also created the bronze sculpture of another famous Scotsman to dwell in the Park, Sir Walter Scott. At the time of the Burns sculpture, Burns had long since died, so Steell turned to the work of another artist, painter Alexander Nasmyth, for reference. Steell developed his own unique vision of Burns as an inspired poet seated on a tree stump as he writes. Unveiled in 1880, the sculpture was praised for its accurate depiction of the poet.

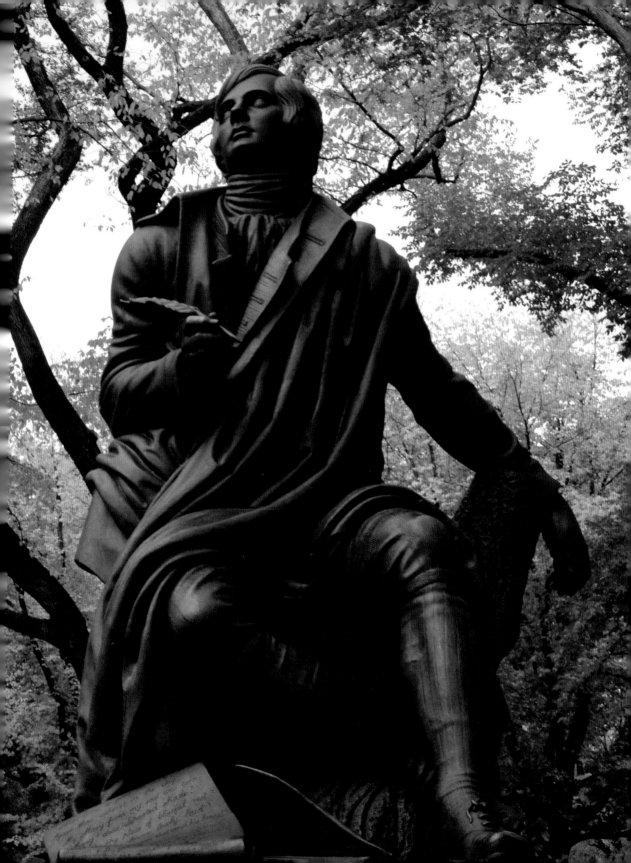

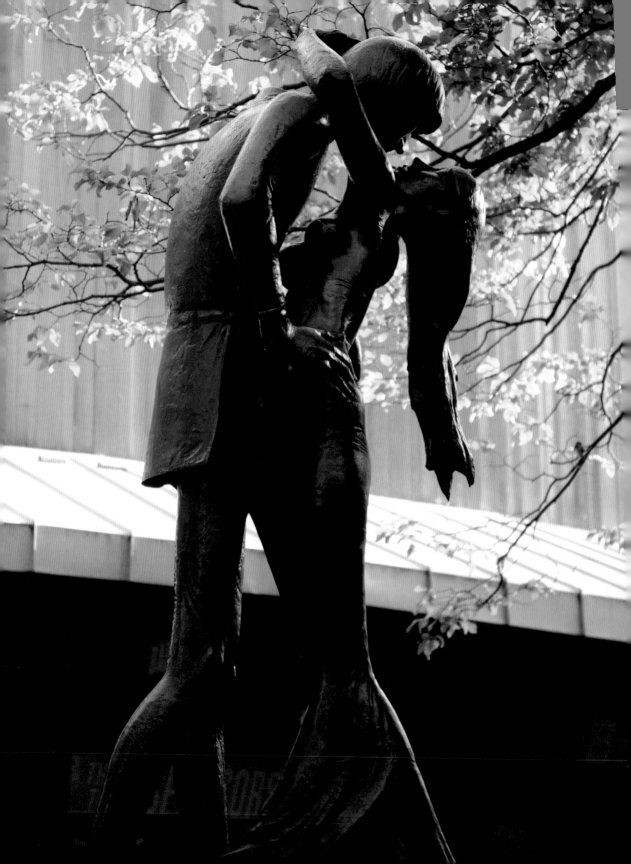

Romeo and Juliet ❧ The Tempest

Exterior, Delacorte Theater

TWO LOVERS—OBLIVIOUS TO THE FUTURE THAT AWAITS them and their own tragic fate—are about to embrace, lost in the moment with one another. These modern, life-sized bronze figures are Romeo and Juliet, from William Shakespeare's famous play of the same name, unveiled in the Park in 1977. A character from Shakespeare's *The Tempest*, which came to the Park in 1966, shows Prospero the magician shielding his daughter Miranda while casting a spell with his right hand (see below).

The characters stand guard just outside Central Park's Delacorte Theater, an open-air venue where the works of playwright William Shakespeare (1564–1616) are presented in the warmer months to the public free of charge. The Delacorte opened in 1962, and the opening night's performance was *The Merchant of Venice*, starring James Earl Jones.

Both sculptures were created by Milton Hebald and commissioned by George Delacorte, who also donated the funds used to construct the theater that bears his name, as well as the *Alice in Wonderland* Statue and the Delacorte Clock. Delacorte was the founder of Dell books, publisher of popular comic books featuring animated characters like Bugs Bunny and Minnie Mouse.

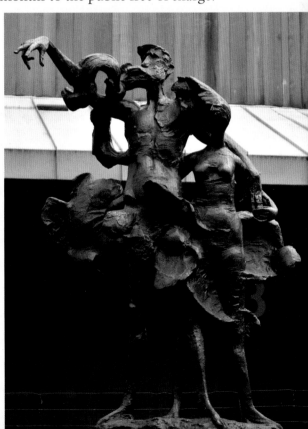

Samuel F. B. Morse

East 72nd Street and Fifth Avenue

T HERE IS NO MISTAKING THE IDENTITY OF THIS BRONZE figure. A massive block of granite elevating the sculpture is carved with the name "Morse" in block capitals, as if the man himself were announcing his presence through the spectacular tool of communication, the single wire telegraph—his own invention.

Born in 1791, American Samuel F.B. Morse was an accomplished portrait painter before he became an inventor, painting a number of notable political figures, including the Marquis de Lafayette. He is also responsible for founding the National Academy of Design in New York City, founded with other American artists, including Thomas Cole.

Morse's commitment to developing a rapid means of communication came about after a terrible tragedy. While he was away from home, his wife became ill. Communication was so slow that by the time Morse learned of her illness via horse messenger, she had already died and been buried. Heartbroken, Morse set about to create a means of rapid communication that would prevent others from losing precious time waiting for important faraway news.

Morse was sculpted in 1871 by artist Byron M. Picket, who showcased Morse's invention, the telegraph, in the sculpture itself: one of Morse's hands rests on the telegraph, while the other holds a scroll dotted with Morse code. The sculpture, unveiled less than a year before Morse's death, was one of the only public honors that Morse received in the United States in his lifetime.

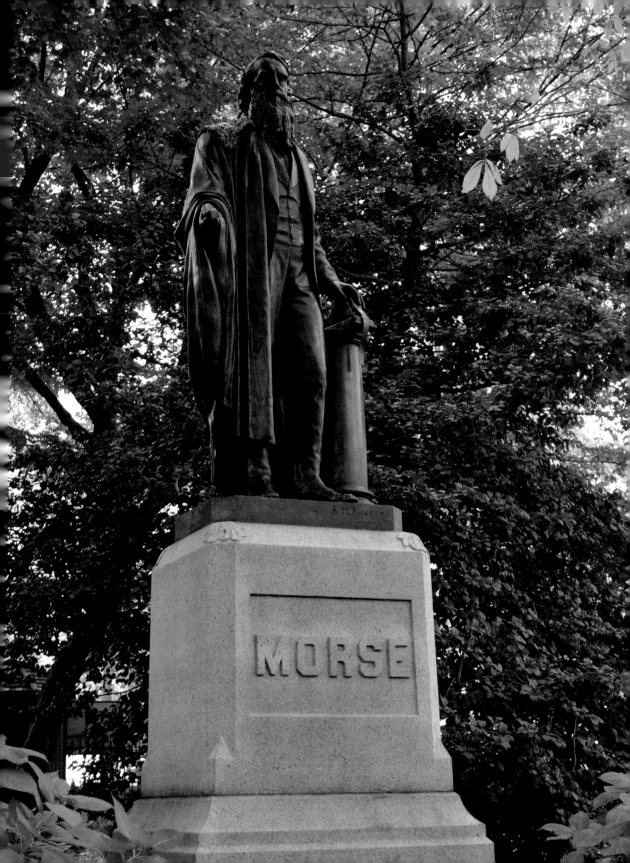

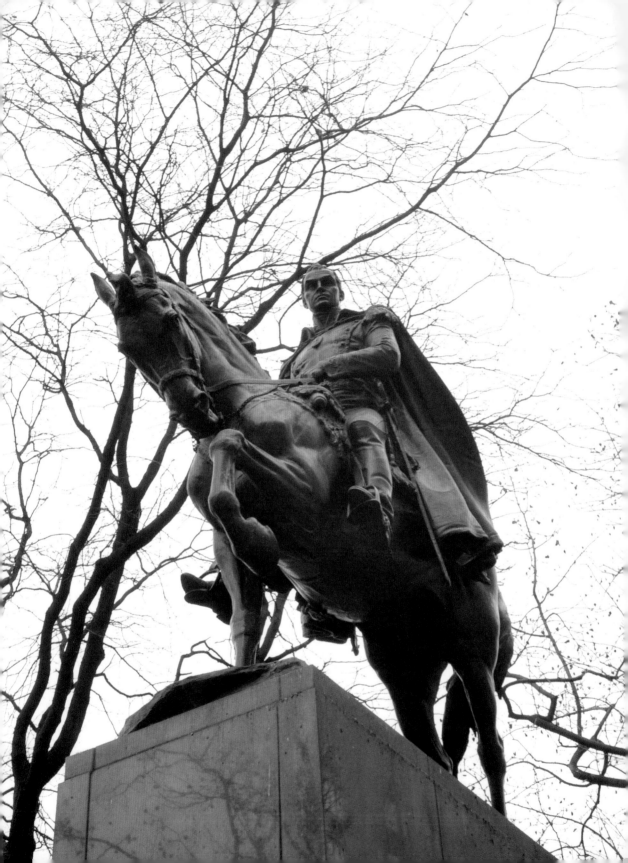

Simón Bolívar

Central Park South and Avenue of the Americas

THE NATION OF BOLIVIA AND THE BOLIVARIAN REPUBLIC of Venezuela are named after Simón Bolívar. A military and political leader known as El Liberator, Bolívar is considered a hero in the Hispanic independence movement for his role in liberating Latin America from Spanish rule. Today, statues of Bolívar stand everywhere from Canada to Italy to Paris, and squares, towns and roads bearing his name can be found in places from New Delhi to Egypt, and even in West Virginia and Ohio.

American sculptor Sally James Farnham created the statue of Bolívar for Central Park and shows the leader in full military dress, guiding his horse with a confident, steely gaze. Cast in bronze, Bolívar towers over the edge of the park on a polished black granite pedestal over twenty feet high.

The sculpture of Bolívar was donated by the Government of Venezuela and dedicated in 1921. It is one of three bronze sculptures depicting Latin American leaders astride horses in Central Park. The other two are of José de San Martín and José Julián Martí.

Sophie Loeb Memorial Fountain

James Michael Levin Playground, East 77th Street and Fifth Avenue

A CHILDREN'S FOUNTAIN DECORATED WITH BELOVED storybook characters is a fitting tribute to a woman who worked on behalf of young New Yorkers: Sophie Irene Loeb (1876–1929). Known as the "godmother of American children," Loeb was a journalist, social worker and both the founder and president of the Child Welfare Board of New York City.

Born in Russia, Sophie grew up in Pennsylvania, where as a teenager she witnessed her family's means of support disappear when her father died. Sophie worked to help support the family, later moving to New York City in 1910. While working as a reporter for the *New York Evening World,* she interviewed many widows who—unlike her own mother—had been forced to place their children into orphanages. Loeb became inspired to fight for change and went on to help set up child welfare boards in every New York county, becoming president of New York City's Child Welfare Board, and helping to found the Child Welfare Committee of America.

Frederick George Richard Roth, who also created the sculpture of Balto and the animals in the Park's zoo, created a memorial to Loeb that features characters from Lewis Carroll's children's story *Alice in Wonderland*. An inscription carved in stone at the base of the statue reads, in part:

IN MEMORY OF SOPHIE IRENE LOEB ... HER GREATEST WEALTH WAS HER HEART OF GOLD.

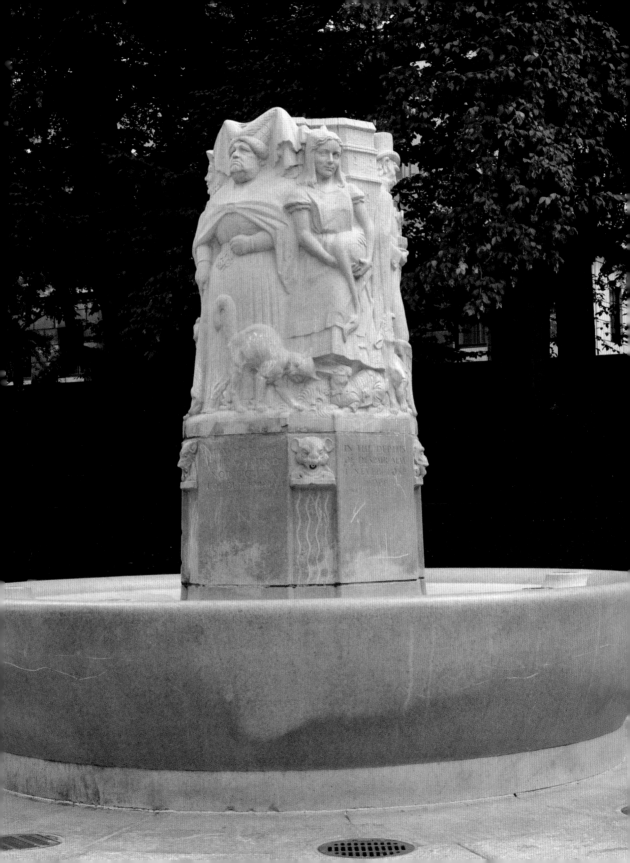

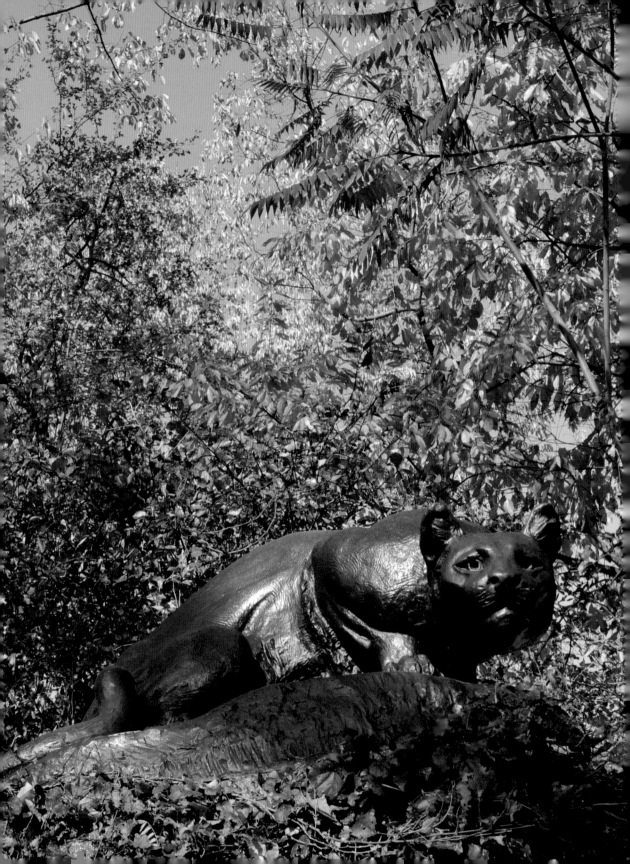

Still Hunt

East Drive, Near 76th Street

STILL HUNT, ALSO KNOWN AS THE PANTHER OR MOUNTAIN lion, has the unique distinction of having scared many Central Park visitors. While other animals in Central Park are elevated on pedestals and bases, the panther of *Still Hunt* is positioned directly on the ledge of a rock on the crest of Cedar Hill. This makes the bronze sculpture seem as if it were a real animal about to pounce.

Before becoming a sculptor, the creator of *Still Hunt*, Edward Kemeys, actually worked as an axman in the corps that prepared the grounds for the construction of Central Park. Kemeys observed many animals in the Park and was inspired in 1869 to become an animal sculptor. Today, 50 of Kemeys' bronzes are in the collection of the National Gallery in Washington, D.C. He also created the lions outside the Art Institute of Chicago and the wolves at the Philadelphia Zoo.

To create *Still Hunt*, Kemeys studied panthers in their native habitat over several years and strove to capture the energy of a predator in the wild. Placed in the Park in 1883, the sculpture was secured to the natural rock outcropping in 1937.

Thomas Moore

Poet's Corner, East of The Pond Near East 61st Street and Fifth Avenue

A FRIEND AND BIOGRAPHER OF LORD BYRON, IRISH POET Thomas Moore was considered Ireland's national bard in the early 1800s. Born poor, Moore worked hard through his education at Trinity College and, by the time he graduated, was already a published poet. He went on to receive critical acclaim for his translation of *Odes of Anacreon,* later writing a series of love poems, composing Irish lyrical melodies, and publishing a history of Ireland and a biography of Lord Byron.

Irish sculptor Dennis Sheahan was commissioned to create the bust of the great poet by The Friendly Sons of St. Patrick. The bust depicts a thoughtful, friendly man, elevated high on a pedestal of Conway green granite, and is inscribed with his name. The sculpture was dedicated in 1880 on the 101st anniversary of Moore's birth.

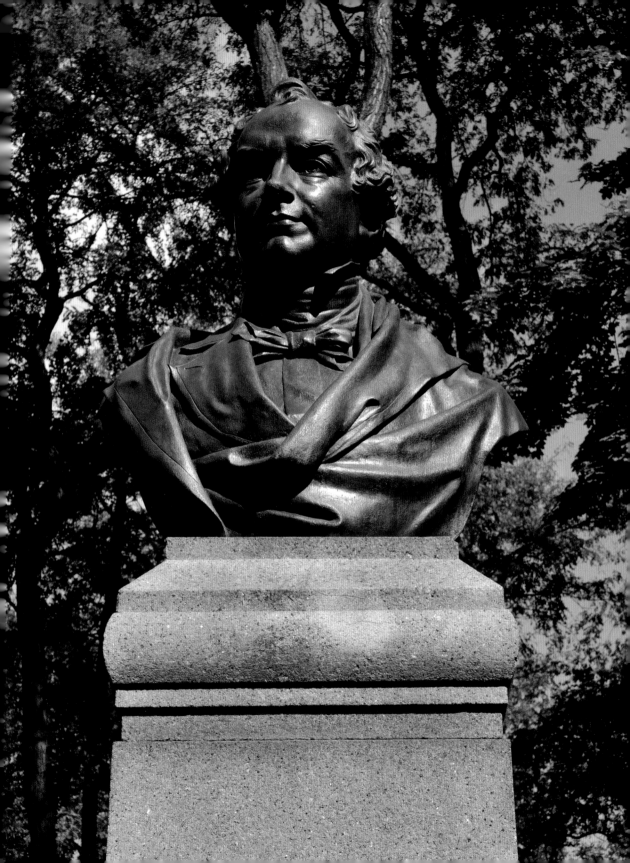

Untermeyer Fountain

Conservatory Garden, East 106th Street and Fifth Avenue

Named for Samuel Untermeyer, the three joyful figures that make up the Untermeyer Fountain are cast from the original sculpture in Berlin, titled *Three Dancing Maidens*, by artist Walter Schott. The Fountain was placed in the Park in 1947, but, to this day, no one knows how Untermeyer obtained the sculpture from the Berlin original or how the cast was made.

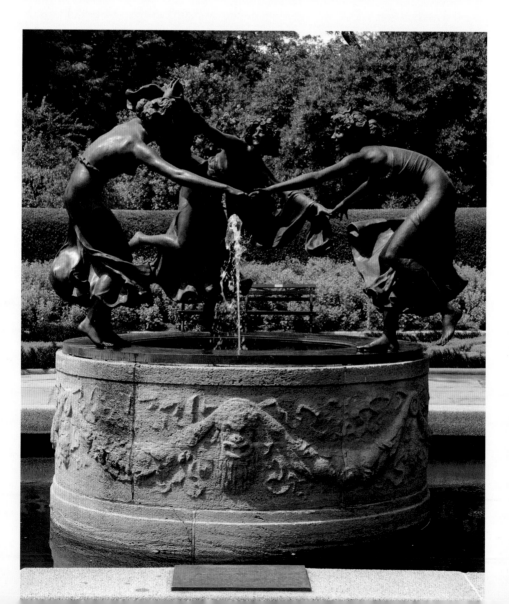

USS Maine Monument

Merchants' Gate, Columbus Circle at West 59th Street and Central Park West

The large marble monument to the *USS Maine*, topped with gold figures sculpted by Attilio Piccirilli, honors the sailors who lost their lives when the battleship *Maine* exploded in the harbor of Havana, Cuba in 1898. The figures at the very top of the monument, said to be cast from metal recovered from the guns of the *Maine,* show Columbia Triumphant being pulled by three hippocampi in a seashell chariot.

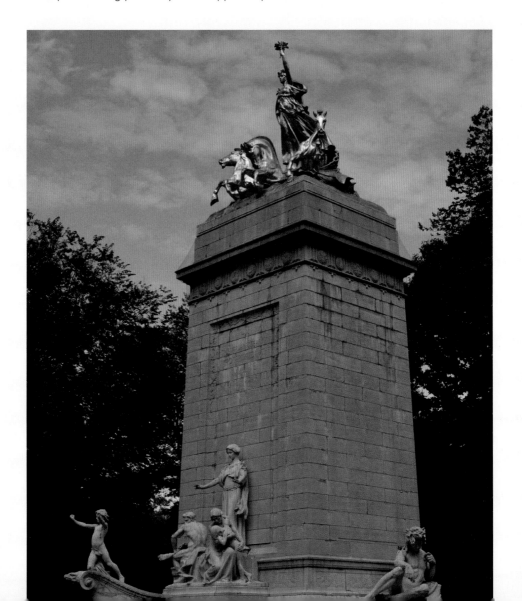

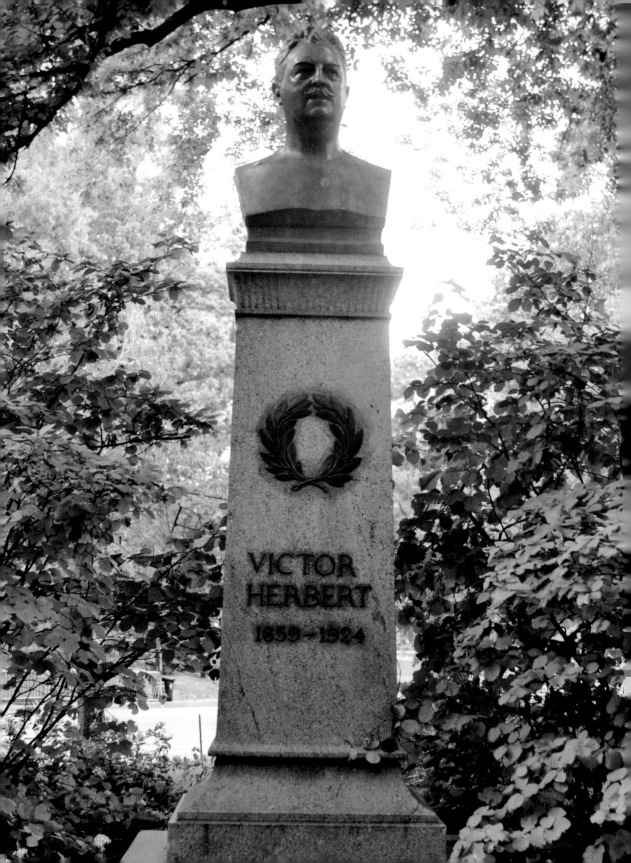

Victor Herbert

The Mall, Across from Naumburg Bandshell

MUSICIANS AND COMPOSERS WHO LIVE AND WORK IN NEW York City owe a great deal to the mustachioed man who looks over the Park near 70th Street.

Victor Herbert was an accomplished Irish-American cellist, conductor, and composer who spent much of his life living and working in Manhattan. Herbert also fought for the rights of musicians, helping to secure the Copyright Act of 1909, which protected the rights of composers to charge royalties on the recording sales of their music. Herbert also worked with Irving Berlin, John Philip Sousa and others to found the American Society of Composers, Authors and Publishers (ASCAP), which works to this day to protect the rights of creative musicians.

Born in Dublin in 1859, Victor Herbert met success as a solo cellist in Europe before moving to New York City in 1886, when he and his wife, a Viennese opera singer, were hired by the Metropolitan Opera. Herbert's career flourished; he became one of the first composers of an original symphonic film score and wrote numerous popular operettas, including *Babes in Toyland*, which was performed in 1903 at the Majestic Theater (located at what is now The Time Warner Center in Columbus Circle) and the Imperial Theatre, which still stands today at 249 West 45th Street. Herbert went on to become the leader of the 22nd Regiment Band of the New York National Guard, conducting concerts at the Central Park Bandstand.

ASCAP commissioned the bust of Herbert by Edmund Thomas Quinn (1868–1929). The bust was erected in 1927, with Arthur Hammerstein and Irving Berlin attending the dedication ceremony.

Sir Walter Scott

East Side at 65th Street on The Mall/Literary Walk

WITH HIS GAZE CAST DOWN AT THE SIDEWALK BELOW and pen and notebook in hand, Sir Walter Scott appears as if he is about to descend from his marble pedestal and walk along the paths of Central Park in his workingman's shoes to gather inspiration. The Scottish novelist and poet known as "The Wizard of the North," Sir Walter Scott (1771–1832) is credited with inventing the historical novel and fostering a nostalgic love of Scotland's rich past.

Born in Edinburgh, Scott explored Scotland's native tongue and rich traditions in numerous written works. In 1802, he issued the first of two volumes of old ballads, and went on to publish a narrative poem in 1805. Longer works *Waverley* (1814) and *Ivanhoe* (1819) followed, along with *Rob Roy* (1817), *The Heart of Midlothian* (1818), and *The Bride of Lammermoor* (1819).

The sculpture of Scott was created by Sir John Steell (1804–1891), the Scottish sculptor who created the image of Robert Burns. The statue in Central Park is a replica of the original, carved in marble and residing in Edinburgh. Steell depicted Scott as larger than life-sized, seated on a rock and wearing a cloak and humble shoes, his faithful dog Maida by his side.

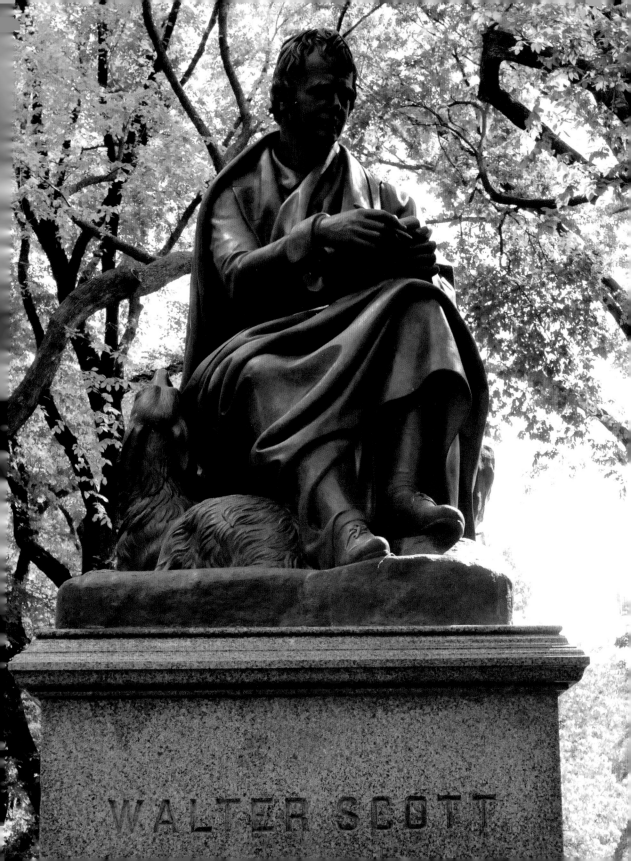

William Church Osborn Gates

Ancient Playground Entrance,
East 85th Street and Fifth Avenue

The bronze *Osborn Gates*, designed by Edward Coe Embury (1906–1990) with sculpture work done by renowned sculptor Paul Manship (1885–1966), depicts several of Aesop's most famous fables, including the tales of the Fox and the Crow; the Tortoise and the Hare; the Peacock; and City Mouse and Country Mouse.

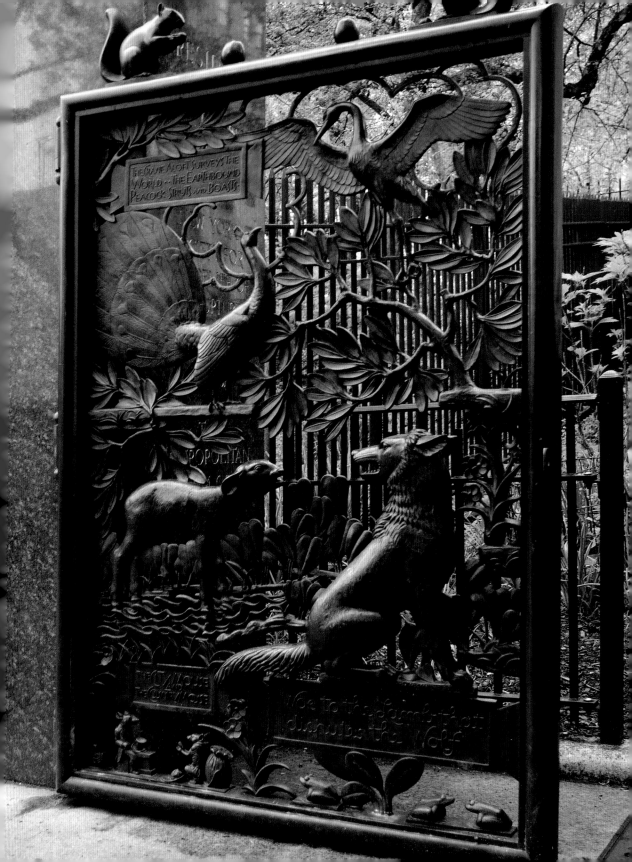

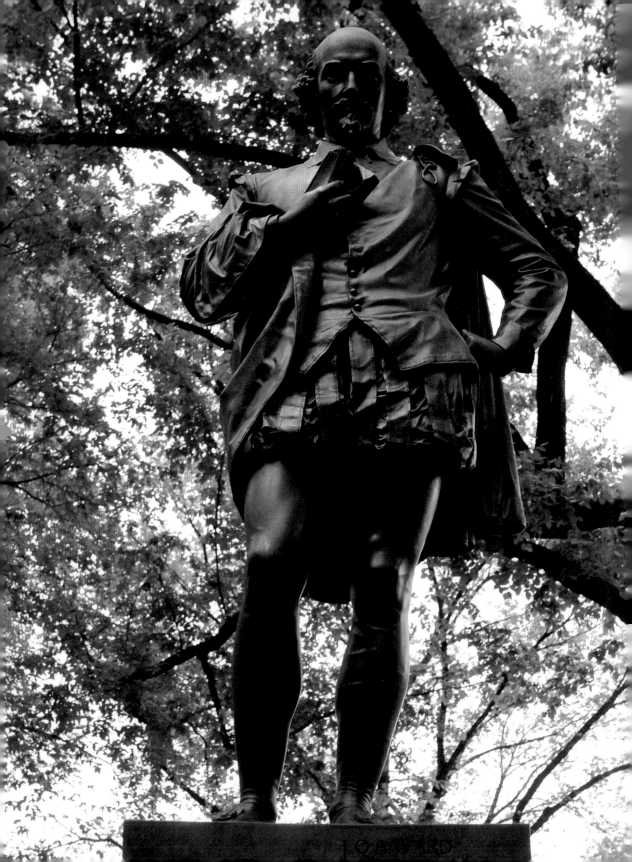

William Shakespeare

The Mall and 67th Street

THE LEGENDARY PLAYWRIGHT AND POET WILLIAM Shakespeare, depicted in Elizabethan dress and holding a book to his chest, is one of the most recognizable on the Literary Walk. The model for Shakespeare was famous American actor James Morrison Steele MacKay. McKay himself suggested the pensive, yet forceful, pose of one hand on the hip with the other hand marking the pages of a book.

Shakespeare's upbringing is not well-known, but his contributions to the history of English literature are unparalleled. A performer at the Globe Theatre in London, Shakespeare was an incredibly prolific playwright, writing thirteen historical dramas and comedies, six tragedies, four tragic comedies and 154 sonnets.

The freestanding sculpture of Shakespeare was the first to be placed in Central Park. Cast in bronze and elevated on a two-toned pedestal of Westerly granite and Rockport granite, the sculpture has been the site of public readings of Shakespeare's work for many years, including readings of excerpts from *Julius Caesar* during the Ides of March.

The sculpture was commissioned to honor the 300th anniversary of the bard's birthday in 1564. Edwin Booth, then America's most famous Shakespearean actor, laid the statue's cornerstone.

William Tecumseh Sherman

Grand Army Plaza, East 59th Street and Fifth Avenue

THE GILDED-BRONZE SCULPTURE OF AMERICAN GENERAL William Tecumseh Sherman shines in bright yellow gold at the entrance to the Park, enlivening the garden at his feet, the Park behind him, and the Plaza Hotel across the street.

One of American's best-known generals, Sherman fought at Bull Run and Shiloh as a brigadier general for the Union Army in 1861. In 1862, as major general, he led his troops on a path of victory through the South, contributing to the eventual defeat of the South in the American Civil War.

Augustus Saint-Gaudens, renowned American sculptor and resident of New York City, was commissioned to portray Sherman. Saint-Gaudens was a great admirer of Sherman, having had the chance to get to know him well while working on a bust of the man from life. Sherman, elderly and living in New York at the time, personally posed for Saint-Gaudens, and, during the series of nearly 20 two-hour long sittings, shared many stories with the artist. After creating the bust, Saint-Gaudens went on to sculpt the general astride a horse in his studio in Paris, laboring for many hours over his creation until the statue's completion in 1903.

Gaudens depicts the General in full military regalia, being led by the allegorical figure of Peace, and had the statue finished with two layers of gold leaf. Saint-Gaudens' sculpture is considered a monumental work of art.

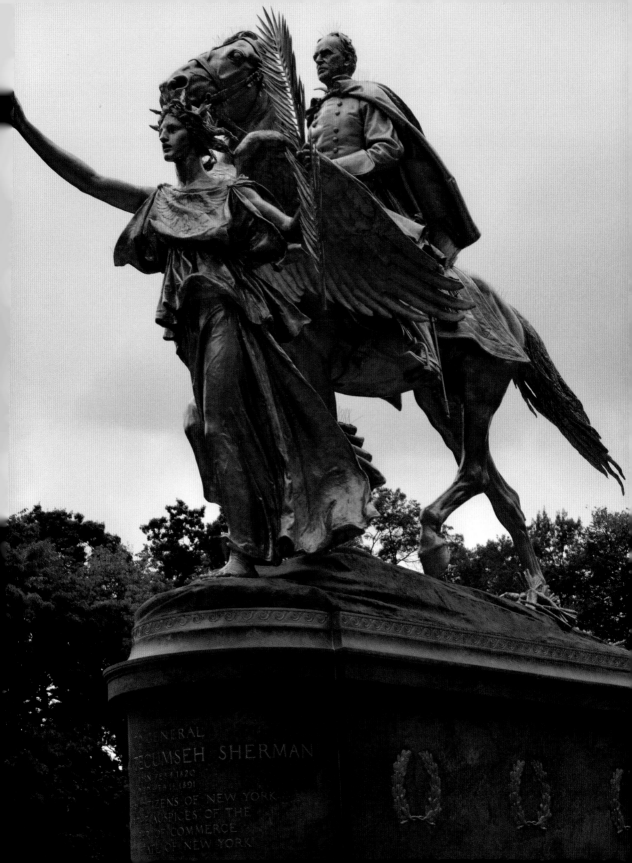

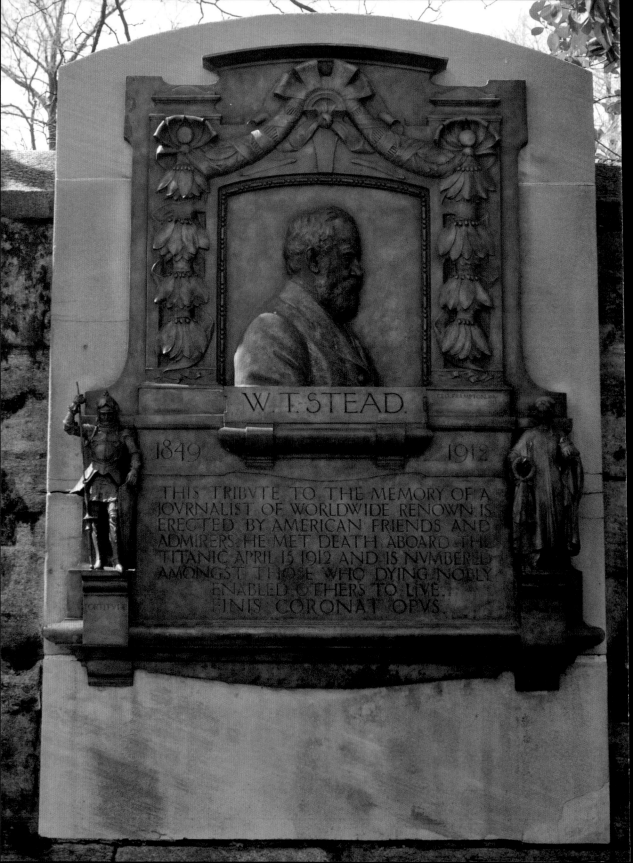

W. T. STEAD.

1849 1912

THIS TRIBVTE TO THE MEMORY OF A
IOVRNALIST OF WORLDWIDE RENOWN IS
ERECTED BY AMERICAN FRIENDS AND
ADMIRERS HE MET DEATH ABOARD THE
TITANIC APRIL 15 1912 AND IS NVMBERED
AMONGST THOSE WHO DYING NOBLY
ENABLED OTHERS TO LIVE.
FINIS CORONAT OPVS.

William T. Stead Memorial

North of Engineer's Gate, East 91st Street and Fifth Avenue

SET IN A STONE WALL NOT FAR FROM THE RESERVOIR IS A detailed bronze plaque, featuring two figures and elaborate decorative foliage, which surround a man in profile. This memorial is a replica of a piece located along the River Thames in London, and honors the British journalist William T. Stead (1849–1912).

Stead introduced investigative journalism to his native country of England and was a great believer in using the power of the press to influence public opinion and change government policy. In 1885, Stead rocked Victorian Britain by uncovering the scandal of child prostitution, and helped to bring about improvements to child welfare. Stead's reports on squalid living conditions in the slums led to improvements in low-cost housing for London residents. Additionally, his innovative vision can be seen on the front page of nearly every newspaper—Stead revolutionized the formatting of newsprint by adding maps and diagrams to text, breaking up longer articles with subheadings, and introducing the form of the interview into reporting.

Stead's life ended tragically when he perished, along with over one thousand others, aboard the Titanic on April 15, 1912. Stead was seen helping several women and children into lifeboats and giving his life jacket to a fellow passenger.

British sculptor George James Frampton (1860–1928) created a memorial to Stead. It features the figures of a knight, representing Fortitude, and an angel, representing Sympathy.

ACKNOWLEDGMENTS

Catarina Astom

THANK YOU TO ANDREW FLACH, MY LONG TIME FRIEND and publisher who originated this idea many years ago. Thank you for providing the opportunity to share in your dream.

Also thanks to the team at Hatherleigh Press for their support and dedication to making this project come to life.

Many thanks to my grandfather Arne Carlsson who told me as a child that everything is possible and to Raeanne Giovanni-Inoue, a photographer and close friend that always is here for me.

A big thanks to Inger and Olle Wästberg for all their support over the years. To Bill and Diana Adams: thank you for caring for me like a daughter of your own.

Thanks to all my New York friends, family and friends in Sweden, and Hobart and its book village which gave me a new view of my old city and Central Park.

Special thanks to my daughter Emilie. I love you to the moon and back. And lastly, thanks to Patrick Germain for all the support, inspiration and love you give me.

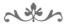

ACKNOWLEDGMENTS

June Eding

THANK YOU TO ANDREW FLACH AT HATHERLEIGH PRESS for the opportunity to write about my favorite park in New York City; thank you to the entire Hatherleigh Press team, with extra thanks to Ryan Tumambing for his assistance and patience with last-minute changes.

A special thank you to my parents, John and Carol Eding, for introducing me to Central Park as a child, and to my brother, John, for always being a fun playmate by the sailboat pond.

And to Jacob: from visiting Turtle Pond in winter, walks through the snow to the Museum of Natural History and sunny afternoons by the Boathouse, thank you for making every visit to Central Park an adventure.